# ELECTRONICS
## FOR ARTISTS

WITHDRAWN

# ELECTRONICS

## FOR ARTISTS

Adding Light, Motion,
and Sound to Your
Artwork

SIMON QUELLEN FIELD

CHICAGO
REVIEW
PRESS

*To Kathleen and Patrick*

Published by Chicago Review Press Incorporated
814 North Franklin Street
Chicago, Illinois 60610
ISBN 978-1-61373-014-0

Library of Congress Cataloging-in-Publication Data
Field, Simon (Simon Quellen)
  Electronics for artists : adding light, motion, and sound to your artwork / Simon
Quellen Field.
     pages cm
  Includes index.
  Summary: "With today's modern technology—LEDs, servomotors, motion sensors,
speakers, and more—artwork can incorporate elements of light, sound, and motion for
dramatic effects. Author and educator Simon Quellen Field has developed a primer for
creative individuals looking for new ways to express themselves though electronically
enhanced art"— Provided by publisher.
  ISBN 978-1-61373-014-0 (pbk.)
  1. Art and electronics. 2. Art—Technique. I. Title.

N72.E53F54 2015
621.38102'47—dc23

                    2014036109

Cover and interior design: Andrew Brozyna, AJB Design Inc.
Cover image: Shutterstock

Printed in the United States of America
5 4 3 2 1

# CONTENTS

# INTRODUCTION

This book is written for artists who want to add light, motion, behavior, or intelligence to their projects. The art might be sculpture that moves, an image that controls its own lighting, an artisan lamp, or a work that responds to the viewer or its environment interactively.

This is not a book "for dummies." However, it assumes that the artist has been educated in art, not science, math, or engineering, and has no prior knowledge of electronics at the level of detail required for building electronic projects. I will do the math for you—a scientific calculator can do any remaining arithmetic. I also will explain why things work, not just how they work or how to build them. Knowing *why* something works will help you remember *how* to make it work.

There is a rule I quote so often that my friends have named it Simon's law: **Nothing is simple.** However, everything can be broken down into pieces that you already know. Each piece then seems simple. I will break down electronics into pieces that you can follow easily. Putting them all back together into a cohesive whole, you will eventually come to think of electronics as something you have mastered, like driving a car, painting a portrait, or planting a garden. None of these things are simple, but they are composed of smaller tasks you have already learned.

# 1

# CREATING LIGHT

Most of what an artist needs to know about electronics is very simple. There may be a lot of little things to play with, but each component is easy to understand.

Start with the *light-emitting diode*, called an LED for short. You put electricity through it, and it lights up. That seems pretty simple.

Like all electronics, LEDs can seem a lot less simple if you don't know their basic rules.

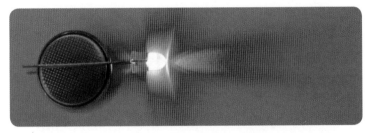

An LED has two wires coming out of it. If you connect one wire to the positive side of a battery, and the other side to the negative side of the battery, you have a 50 percent chance it will light up. If it doesn't light up, turn the battery around and it will.

**The first rule of LEDs** is the *diode* part of the name at work: a diode only allows electricity to go through it in one direction.

The tiny little button-cell battery in the photo above is just strong enough to light the LED. What would happen if you connected the LED to the battery in a car, or to a 9-volt battery? That would not be a good idea. At best, the LED would make a little pop sound and become a dark-emitting diode, which we will call a DED.

**The second rule of LEDs:** they can only handle a certain amount of electricity.

Electricity is just moving electrons. As electrons move through a conductor such as a wire or an LED, they bump into the atoms in the conductor, causing the conductor to heat up. The temperature rises, but as the temperature becomes higher than that of the surroundings, more of the heat is lost to the environ-

ment. So eventually, the LED reaches a stable temperature, where the amount of heat generated equals the amount of heat lost.

Each second, some number of electrons move through the LED. If the number of electrons per second goes up, so does the temperature. At some point, the temperature of the LED is so high that the little chip inside the LED breaks or the tiny little wires that connect to the top of the LED chip simply melt.

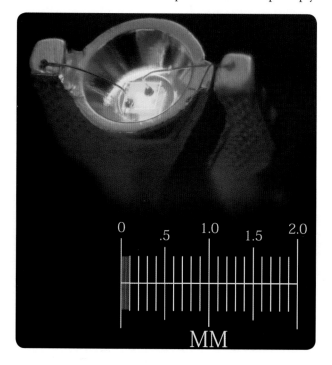

You can see two of those tiny little gold wires in the photo enlargement above. A yellow LED chip is glowing inside the small reflector cup. The entire LED is usually encased in a plastic lens, making it very difficult to see. But for this photo, I placed the glowing LED in some oil so that you could see through the plastic easily.

Just as a current of water is measured by how many gallons flow by each second, currents of electricity are measured by how many electrons flow by each second. Electrical current is measured in units called *amperes*.

The LED shown can handle about 0.030 amperes (30 milliamperes) before it overheats. Knowing that, you then need to make sure that no more than 30 milliamps go through the LED. You do that by adding a resistor.

A *resistor* is a bottleneck for electric current. A resistor can be something as simple as a narrow wire. The thinner the wire, the less electricity can go through it.

Low resistance                         Low resistance
                  High resistance

You can also make a resistor by using a wire made from something that elec-
trons have a difficult time moving through. Carbon is such a material. It is made
up of many little grains, and where the grains touch, the electrons can go from
one grain to the next. However, the grains only touch in tiny spots, just like two
balls can only touch in one tiny spot when put together. In this way, they restrict
the flow of electrons like the thin wire does. Materials like carbon also hold on
to their electrons more tightly than copper wire does, so there are fewer electrons
available to move.

So you could try lighting an LED from a 9-volt battery through a resistor to
keep the current below 30 milliamps. But how much resistance would you need?

A 9-volt battery pushes electrons through an LED three times harder than
a 3-volt battery does. *Voltage* is just the pressure on the electrons. If you put
more pressure on the electrons, more of them will flow through the resistor, and
through the LED in each second.

To figure out how much resistance you need to add, you can measure the
current in your circuit while you gradually reduce the resistance, until you get
to the value you want.

I picked a few resistors almost at random to try in the circuit. Resistance
is measured in ohms, and I picked two resistors with 220 ohms and one with
1,000 ohms. Resistors have color codes to tell you what values they are, and
the two 220-ohm resistors have the color code red, red, brown, gold. You can
memorize the resistor color codes or print them out on paper (see page 13 for
more information), or you can just use a multimeter, which can measure the
resistance directly.

Once you've chosen your resistors, you need a way to create the circuit con-
necting them, the battery, and the LED. The projects discussed in this book are
going to use *solderless breadboards* a lot, since they make building such circuits
much easier. A solderless breadboard has rows of holes you can poke wires into.
On the edges are two rows of holes that are all electrically connected to the other
holes in the same row. In the middle are numerous groups of holes in columns
of five; each of the holes in a column is electrically connected to the other holes
in the same column. If you put a wire into one of the five holes and a second
wire into another of the same group of five, the two wires will be electrically
connected.

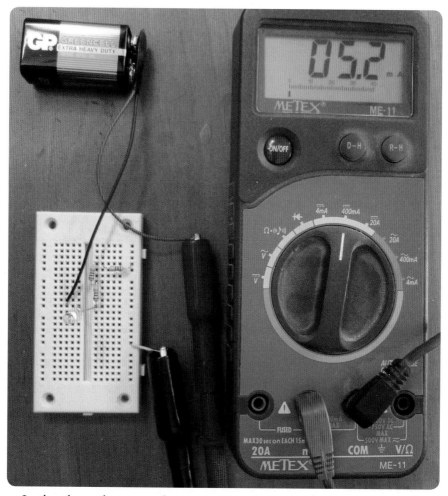

In the photo above, my three resistors are connected to a battery, an LED, and a multimeter via a solderless breadboard. The resistors are the small brown tubes at the center of the breadboard (note the color-coded stripes). The electrons come out of the battery through the black wire. They then go through the LED. From there they go through one 220-ohm resistor, then the other, then the 1,000-ohm resistor, and then (via the yellow wire) into the multimeter. Finally, they exit the meter and return to the battery. They make the full circle through all the parts and back to the battery through the red wire. This is why it is called an *electric circuit*.

To help you understand how solderless breadboards are constructed, the photo below shows one where I have removed the sticky tape from the back so that you can see the rows and columns of metal connectors joining all the holes.

Each connector is a U-shaped bit of metal that is springy enough to open up a little when a wire is pushed into it but strong enough to hold the wire in place.

Now back to the original circuit. The meter is showing that there are only 5.2 milliamps flowing through the LED and the resistors. Since you wanted 30 milliamps, you know that you have too much resistance.

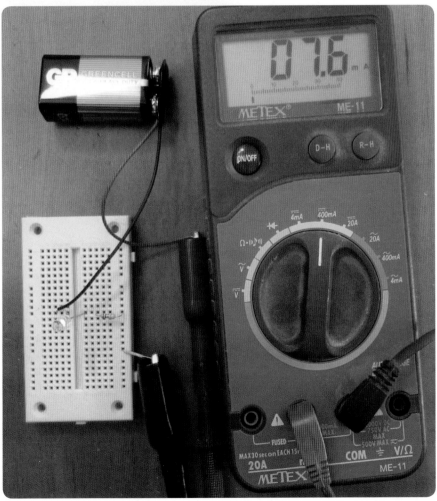

Try using just the 1,000-ohm resistor. The photo on the previous page shows the meter reads 7.6 milliamps. That is a little closer but still not the 30 milliamps you want. You want the LED to glow as brightly as it safely can.

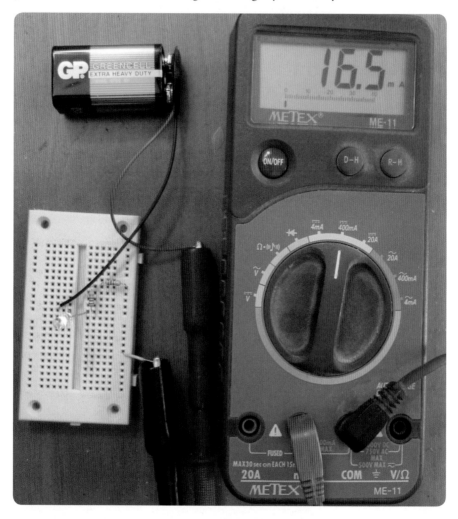

The photo above shows the circuit with just the two 220-ohm resistors (440 ohms altogether). The meter is showing 16.5 milliamps, more than half of what you are aiming for. What happens if you use just one of the 220-ohm resistors?

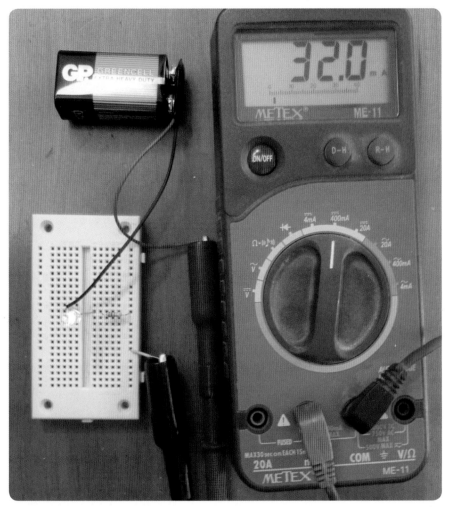

Oops! You overshot the mark . . . but not by a lot. You are only high by a little less than 7 percent, and the LED can handle that. No popping noises, no dark-emitting diodes. Success!

Rather than do all of that resistor swapping and guessing, wouldn't it be nice if you could just plug in the voltage you have, and the current you want, and have a calculator figure out what resistor to use? You can, but to figure out what to enter into the calculator, you need to know a third rule about diodes.

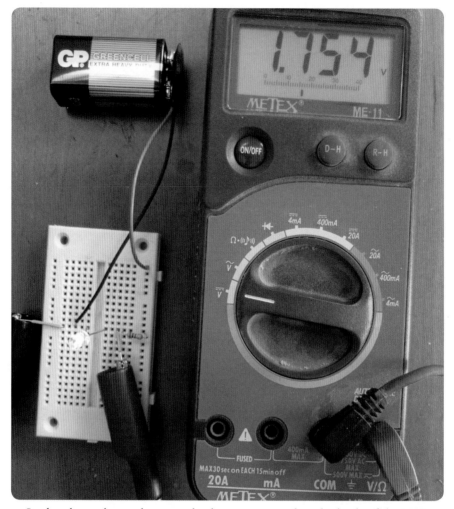

In the photo above, the meter leads are connected to the leads of the LED in the circuit. The multimeter has been switched to read volts. The meter tells you that the voltage difference between those two spots (the two legs of the diode) is 1.754 volts. Each different kind of diode has a characteristic voltage, called the *forward voltage drop*. For red LEDs, it is about 1.75 to 1.8 volts. For other colors, it is higher as the colors go through the spectrum. Green LEDs might be 2.3 volts. Blue LEDs are around 3 volts. The voltage drop can be measured, as you just did, or you can just read it on the back of the LED package.

Now you have enough information to use a calculator.

**The resistance you need is the voltage divided by the current.** This is called Ohm's law, named after scientist Georg Ohm, who worked it out.

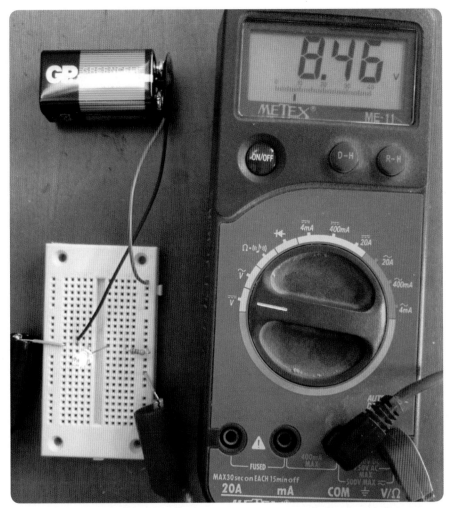

The voltage is the voltage of the battery minus the voltage drop of the diode. In this case, the battery voltage is 8.46 volts (you can measure it in your circuit, as I did in the photo above). Subtract 1.754 volts and get a little over 6.7 volts. If you divide that by 0.030 amperes (the current the LED can handle without overheating), you get about 224 ohms.

If you have a computer or a smartphone, Google can help you do the calculation. Google knows that volts divided by amps gives you ohms. Try typing the following into Google:

**(8.46 volts - 1.754 volts) / 30 milliamps**

In this circuit, you found that you got 32 milliamps from your 220-ohm resistor. You can ask Google to give you the voltage:

**32 milliamps * 220 ohms**

Google says the result is 7.04 volts. But you expected 6.7 volts! What went wrong?

Let's check the resistance by connecting the resistor directly to the meter:

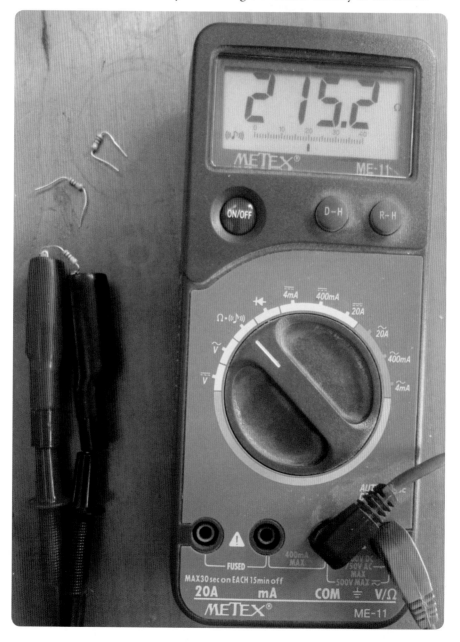

It turns out the resistor wasn't actually 220 ohms. It was 215.2 ohms. Ask Google again:

**32 milliamps * 215.2 ohms**

Oh, good! Now you get 6.8864 volts, which is very close to the 6.7 volts you expected.

The gold band on the resistor tells you that the resistor has a *tolerance* of 5 percent, which means its actual value will be within 5 percent of the value coded in the color codes. In this case, it is 2.2 percent off. You can expect a certain amount of sloppiness in your measurements—meters are not perfect, and the connections you make are not perfect—and in your parts values, such as in the case of this resistor. And you saw that your LED could handle 32 milliamps instead of the 30 the package recommended to limit the current to. When your parts are specified to only 5 percent accuracy, you can tolerate that much slop in your results.

**10 volts / 50 milliamperes is 200 ohms.**

**2 amperes * 300 ohms is 600 volts.**

**120 volts / 2000 ohms in milliamperes is 60 milliamperes.**

Memorize the following three relations, which will allow you to calculate any of the three measurements as long as you know the other two:

**resistance = volts ÷ current**

**voltage = current × resistance**

**current = volts ÷ resistance**

Or, if you memorize just one equation, a little algebra will allow you to rearrange the terms and arrive at the other two. On the other hand, you can just tell Google to multiply or divide the two measurements you have, and if the answer isn't in the units you're missing (volts, ohms, or amperes), you change the multiply to a divide, or vice-versa. In other words, even if you hate algebra and hate memorizing, you can still work it out.

## COLOR CODES

Resistors are rather small things. Not only would it be difficult to print the resistance value on them, but also that value would be difficult to read. On a crowded circuit board, you might also have to turn your head different ways to read different resistors, and the printing might not be on the side facing you.

To get around these difficulties, manufacturers use the aforementioned color code. It's not that hard to learn, but if you don't use it every day, you might find yourself learning it over and over again.

The website that accompanies this book has a page (http://artists.sci-toys .com/calculate_resistance.php) with an interactive tool that allows you to find the resistance you need and to quickly use color codes in a painless manner:

# Resistor Color Code Tool

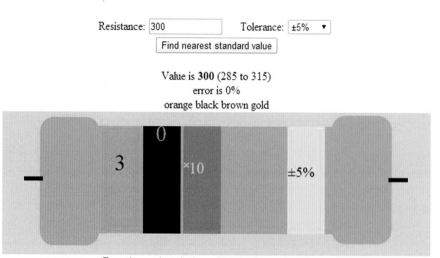

Drag the numbers in the resistor to change the values.

The first two bands indicate a numerical value—30 in the example above. The third band is a multiplier—you multiply the number from the first two bands by this amount to arrive at the value of the resistor. In this case, the multiplier is 10, so the value is 30 × 10, or 300 ohms.

The last band is the tolerance—as mentioned earlier, the allowable difference between the resistor's coded value and its actual value. The most common resistors have a tolerance of plus or minus 5 percent. As a result, resistors are not made in all possible values; there is no reason to make a 105-ohm resistor if you are already making 100-ohm and 110-ohm resistors. You can buy more expensive resistors that have closer tolerances, but for the most part the 5 percent resistors will be all you really need.

The color coding makes it easier to find the resistors you need in a pile on the table. You look first for the multiplier band, and that gets you to the approximate value you need. Then you look at the first few bands to narrow the search to the exact value you need. In many cases, you will be experimenting and the exact value may not matter at first; you can just look at the multiplier band and test a resistor with the appropriate multiplier in your circuit. Once you test that resistor, you can look at the first two bands and find one with the same multiplier but a slightly larger or smaller value.

Rather than write lots of zeros for the larger values, resistors are described in terms of *kiloohms* (or *k-ohms*) and *megohms*, for multiples of 1,000 (kilo) and 1 million (mega).

# PROJECT: ELECTRIC FLOWERS

Adding LED lighting to small art pieces can transform them. A nest of hollowed-out chicken eggs can make one statement by day . . .

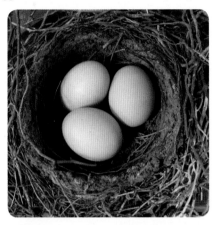

. . . and look entirely different at night.

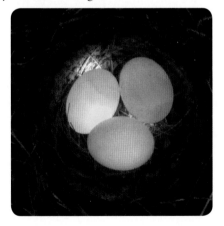

If you want to make your own glowing nest, carefully make a hole in the side of an egg (not one of the ends) a little larger than the LED you will be inserting. About an inch from that, make a smaller hole to allow air to come in as you suck the contents out of the egg. A little washing, and you can insert an LED inside—a high-brightness white LED in this case. Add a current-limiting resistor and a battery and you are all done. I used sandpaper to rough up the clear surface of the LEDs to make them diffused, since most super-high-brightness LEDs are water clear.

This first project, however, is Electric Flowers. You will hide bright, colored LEDs inside origami flowers and arrange them in a vase made from a recycled bottle.

First, select a power supply. You don't want to be constantly changing batteries, so use a 9-volt plug-in power supply from an old toy. These are often referred to as "wall warts," since the transformer and other electronics that reduce the wall socket power down to (in this case) 9 volts are hidden in a plastic shell that plugs into the wall. ***Make sure you're using a 9-volt wall wart***; you should of course never use a plain cord plugged into the wall, which carries 100 or 200 volts of AC power.

The LEDs shown in this project have a forward voltage drop of 3.6 volts. So the voltage needed for the current calculations is: 9 volts – 3.6 volts = 5.4 volts.

These LEDs are rather robust and can handle 200 milliamperes of current, glowing quite brightly when they do. They will eventually die after a few hours, but for a short time, they can handle the high current. If you want a more lasting bouquet, use more resistance—limit the current to 30 milliamps per LED—and simply use more LEDs if you want more light. I used the high current to make them more visible in the photographs.

Divide 5.4 volts by 200 milliamps to get 27 ohms; that is what you select as your current-limiting resistor.

Solder the resistor to one lead of the LED (either lead will do, it doesn't matter which). Solder a couple of wire leads to the LED and the resistor to act as the stem of your flower. I used the green pair from a short length of CAT5 network wire, because I happen to have lots of that around. Any insulated wire will do, but it should look nice.

Earlier I made some origami flowers out of plain white paper. There are many sets of instructions online for making hundreds of different types of origami flowers, so I won't repeat those instructions here. But select a deep flower type that can hide the LED easily.

Cut the bottom of the flower off so that there is a small hole just big enough for the wires, but not the LED, to fit through. Push the wires through, and pull until the LED fits snugly inside the flower. Use some transparent tape to hold it in place. Then cut about a 1½-inch length of plastic straw to pull up over the wire ends to hide the connection.

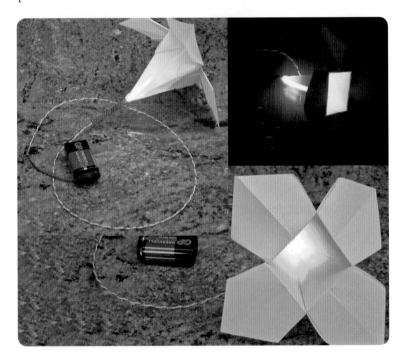

In the photo above you can see a blue flower from a couple different angles, and in the dark. It is powered by a 9-volt battery for testing.

To complete the project, drill a hole in the bottle near the bottom, so the wires from the wall wart power supply can be threaded through (remove any connector from the end of the wire). Then solder all of the positive flower wires to the positive side of the power supply and all the negative wires to the negative side, making sure they all light up and no wires are swapped. Insulate the soldered connections with a little electrical tape and pull the wires down into

the bottle to hide them. The flowers droop over the bottle to illuminate the table under them, like little nightlights. You can see the pool of red light under the flower on the right in the following photo even in the daytime. The other flowers are bell shaped and hide more of their light inside.

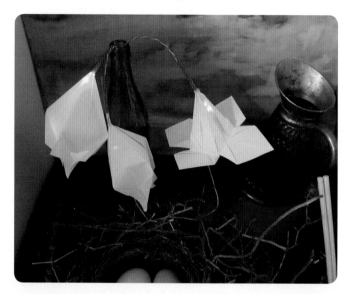

At night, the flowers glow.

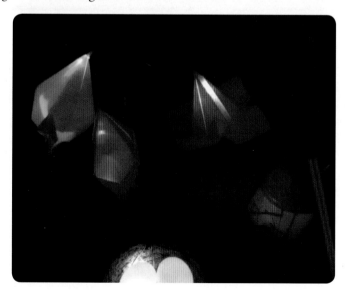

## STUDENT ART PROJECT

*Collateral Damage* by Bethany Carlson Mann is an example of how simple LED circuits can add depth and life to a piece.

# 2

# CONTROLLING ELECTRICAL CURRENT

When you were working with LEDs, you tried to keep the current limited to 30 milliamperes. You got this number by looking at the specifications of the LED on the back of the package. But sometimes you get parts that have no detailed specifications, or you are reusing a part from some scavenged bit of electronics. How can you make sure you don't damage the part by using too much current?

Use a pocket laser pointer as an example. These little devices normally run on tiny button-cell batteries. Small batteries like this might have the same output voltage (about 1.5 volts) as larger cells such as C or D flashlight batteries, but they can't supply the same amount of current as the larger cells. If you wanted to power a laser pointer from a larger battery, in order to get longer battery life (or because the larger batteries are cheaper and easier to find), you could burn out the laser immediately if you connected it to the larger cells.

Pocket laser pointers are similar to LEDs in many ways. They use diode lasers, which are made of the same materials as LEDs. In fact, if you use low currents, a laser will just glow like an LED. But the laser diode chip is built in a special way, with the faces of the chip cut to make mirrors that bounce the light back and forth, allowing the light to be amplified until it is so bright that it escapes through the mirrors in a bright beam. This laser amplification happens only when the current is so high that the chip is very close to burning out. This makes controlling the current all the more important.

Now see how much current the laser pointer uses when in normal operation. To do this, you need to put your meter *in series* with the batteries (between the battery and the rest of the circuit), as you did with the LEDs. Simply use some tape to bind the three little batteries together and some alligator clips to connect them to the little spring inside the laser's battery compartment and to the case of the laser. Use a bit of tape to hold down the power button so the laser stays on.

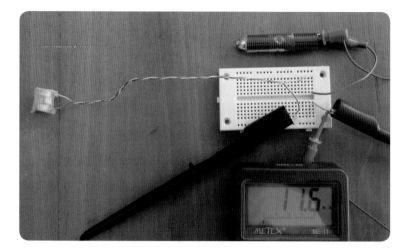

The current (in this case, for this laser and these batteries) is a little under 12 milliamperes. Compared with the LEDs, it is using only about a third as much current.

If you have two meters, you can measure the current and the voltage drop across the laser diode at the same time.

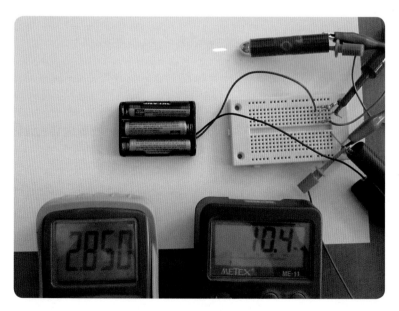

Here you can see I've made a few changes. Instead of the little batteries, I am using flashlight cells. I have added some resistance to keep the current to something close to what the laser normally encounters. I started with one resistor for

safety, so the current would be too low to operate the laser. Then I added more resistors *in parallel* (instead of in series), which reduces the resistance (and thus increases the current) gradually. Adding resistors in parallel gives the electrons more ways to get through, so the current increases and the resistance decreases. (For more information on resistors in parallel, see page 29.)

The voltage drop is about 2.85 volts. When you learned Ohm's law in the previous experiments, you saw that if you double the voltage going through a resistor, the current doubles as well. Since this makes a straight line when graphed, the relationship is *linear*. With a diode, the relationship is definitely not linear. As you double the voltage, the current through a diode goes up exponentially. This is what is really going on with that forward voltage drop. The diode seems to let all the current go through it once the voltage reaches the forward voltage drop level.

This is why it is important to limit the current using the resistors. Otherwise, the diode will allow all the current the battery can generate to go through it, and it will heat up until it fails.

Different diodes have different behavior with respect to voltage and current. They are exponential, but some more than others. The laser diode I'm using is not just a diode—it has a resistor built into the circuit inside it to limit the current from the tiny batteries. So as you increase the current, the forward voltage drop also increases.

Let's risk burning out the laser and see if it can handle the same 30 milliamperes that the LED could.

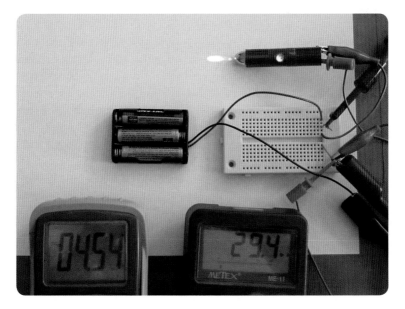

It can, although for how long we don't know. It may last years at its normal current but only days or weeks at this higher current. But it is three times brighter than it was before.

Lasers have a voltage called the *threshold voltage*, below which there is not enough current for them to act as lasers. They act like ordinary LEDs below that current.

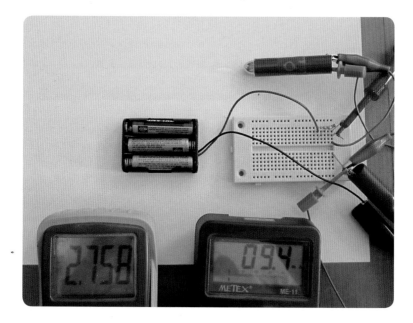

Here I have lowered the current to 9.4 milliamperes, and suddenly the laser is much dimmer. When a laser beam hits a rough surface, you can see many tiny sparkles. These are called *laser speckles*, and they're caused by the reflected light from the high points interfering with the reflected light from lower points on the rough surface. They are a hallmark of laser activity. But below the threshold current, you won't see the speckles. This fancy laser is now just an ordinary LED. It is suddenly much dimmer because the light is not being amplified by the laser activity in the diode.

Once the voltage is above the threshold, the light output of the laser is linear with the current. So if you let three times the current go through, then the laser will be three times brighter. It looks like the manufacturers of this laser pointer kept the current very close to the threshold. This lowers the brightness (making the laser safer to use as a toy) and increases the battery life.

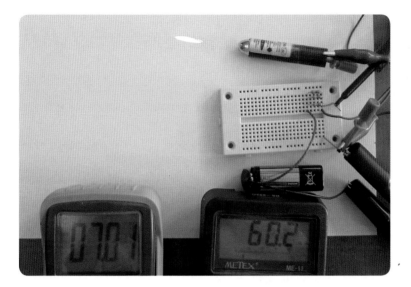

Here is the laser operating at 60 milliamperes. It is well over five times as bright as when using the normal batteries. I had to use a 9-volt battery to get to this current level.

The 9-volt battery will last only an hour or so at a discharge rate of 60 milliamps before its voltage drops so much that it can't drive the laser. In the few minutes I was driving the laser at this rate, I could see the current steadily dropping as the battery discharged. And I would not expect the laser to last very long either.

So far, you have been using resistors to limit the current in LEDs and lasers. In this section I used resistors in parallel to get a lower resistance. I could have simply found a resistor with a lower value and used that. But when experimenting, it is handy to know how to quickly change resistances by putting resistors in series to increase the resistance, or in parallel to reduce it.

Schematic symbol for a resistor

If you put one resistor after another, in series, then they both reduce the current flow. If they are both the same value, the resistance of both together is twice that of either one. In fact, you can place any number of different-valued resistors in series, and the resulting resistance is just the sum of all their individual resistances.

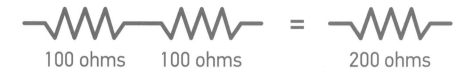

100 ohms        100 ohms        =        200 ohms

Resistors allow fewer electrons to flow than a plain wire would. If you place two resistors together in parallel, the current has twice as many routes it can take. If the resistors have the same value, it is easy to see that together they will have half the resistance.

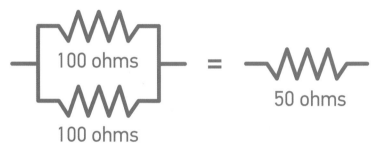

100 ohms

100 ohms        =        50 ohms

Before this discussion of resistors ends, there is one more neat trick you can do with them. If you have one voltage, perhaps the voltage of a 9-volt battery, but you need a smaller voltage, you can use two resistors to divide the voltage in half:

+9 volts

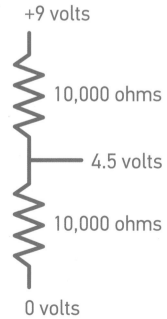

10,000 ohms

4.5 volts

10,000 ohms

0 volts

But it gets better. The voltage in the middle can be any voltage from 0 to 9 volts. Divide the resistance of the bottom resistor by the total resistance (both resistors added together). Multiply that by the input voltage to get the output voltage. So if you wanted 3 volts, you could make the bottom resistor 10,000 ohms and the top resistor 20,000 ohms, because 10,000 ohms divided by 30,000 ohms is ⅓, and ⅓ of 9 volts is 3 volts. Or you can ask Google to do the arithmetic.

**(9 volts * (10000 ohms)) / (30000 ohms) =**

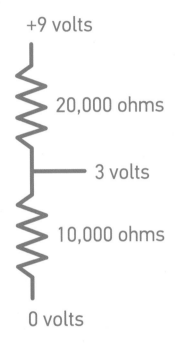

So why did I suddenly start using such large values for resistance? Look at what the circuit does. It connects one side of the battery to the other, through two resistors. If the resistance was low, a lot of current would flow. That would heat up the resistors, and they might even catch fire. But with 30,000 ohms of resistance and 9 volts, Ohm's law tells you that you will have a current of 0.3 milliamps. The resistors won't heat up much at all, and the battery won't quickly drain.

## HOW BRIGHT IS THAT?

When selecting an LED, you might like to know just how bright it will be when you get it built into your circuit. And the package tells you—it might say something like "10,000 millicandelas." But how bright is that?

To describe how bright something is, it helps to have something to compare it to. Illumination is measured in units called *lux*. Walking outside in the sun, you are experiencing between 30,000 to 100,000 lux. In a well-lit office, you are in about 1,000 lux. Walking in the moonlight, you are getting only about 1 lux.

If you are trying to light your office with a lamp, and you want 1,000 lux on your desk, you will need to know how much light the lamp produces and how far away from your desk it is. How much light a lamp produces is measured in *lumens*. A 60-watt incandescent bulb might produce 850 lumens. A 100-watt incandescent might produce 1,700 lumens. To get an illumination level of 1,000 lux on your desk, you can put a 60-watt bulb about 12 feet away.

An LED might put out about half a lumen. That doesn't sound like a lot. But the LED has a little lens in front of it that focuses the light in one direction. So now, all of the light is falling in a smaller area, giving better lighting to that area. To take into account that focusing of the light, LEDs are measured in *candelas* (or millicandelas), which are lumens focused on a spot.

All of this sounds complicated. So I have built a little gadget to help out. You can find the gadget on the website that accompanies this book (http://artists .sci-toys.com/how_bright).

With the gadget (an example follows), you can move the sliders back and forth to play with the different lighting concepts. You can change the amount of light, how far away it is, and how focused it is. At the right, you will see the resulting illumination, in lux, and the size of the illuminated spot.

## STUDENT ART PROJECT

In *Dark Ride* by Bethany Carlson Mann, the tiny dancers inside the animal's mouth move as the viewer turns the hand crank in the front. The LEDs and fiber optics give the piece the required magical aspect when the house lights dim.

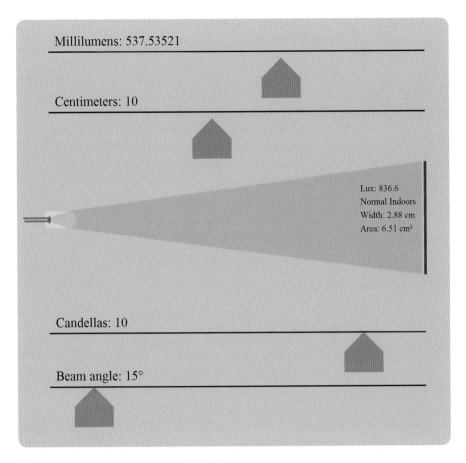

Millilumens: 537.53521

Centimeters: 10

Lux: 836.6
Normal Indoors
Width: 2.88 cm
Area: 6.51 cm²

Candellas: 10

Beam angle: 15°

## RESISTORS IN PARALLEL

If you have many resistors in parallel, the arithmetic is easier if you work with conductance instead of resistance. The two concepts are really just different ways of looking at the same thing—*conductance* is how easily the electrons can flow, and *resistance* is how difficult it is for the electrons to flow.

Resistance is measured in ohms, and conductance is measured in *siemens*. Normally you won't be using siemens, but I introduce it here because it makes calculating parallel resistances easier. To convert resistance to conductance, you simply take the reciprocal—that is, you divide 1 by the number of ohms.

To get the value for the conductance of parallel resistors, you simply add them. This makes parallel resistors as simple as series resistors, as long as you are using conductance instead of resistance.

Take a look at the earlier example of two 100-ohm resistors in parallel (page 26). Each resistor has a conductance of 0.01 siemens (1 ÷ 100 ohms). Add-

ing them together in parallel makes the combination more conductive, yielding 0.02 siemens (1 ÷ 100 ohms + 1 ÷ 100 ohms). Taking the reciprocal of that to convert back to ohms yields 50 ohms (1 ÷ 0.02 siemens).

If you like, you can still just work in ohms. To find out the resistance of a 100-ohm resistor in parallel with a 200-ohm resistor, add 1 ÷ 100 ohms and 1 ÷ 200 ohms and then divide 1 by that. To put it in a simple formula:

**resistance = 1 ÷ (1 ÷ resistor 1 + 1 ÷ resistor 2)**

It's only a bit more complicated than working with conductances, but it is easy to enter into a scientific calculator, yielding a result of 66.67 ohms.

In mathematical form, it looks like this:

$$\text{resistance} = \cfrac{1}{\cfrac{1}{\text{resistor 1}} + \cfrac{1}{\text{resistor 2}}}$$

Which can be rearranged as:

$$\text{resistance} = \frac{(\text{resistor 1})\,(\text{resistor 2})}{\text{resistor 1} + \text{resistor 2}}$$

This latter form is called the *product over sum* method, and many electronics students memorize it and have no idea how it comes about, or that understanding parallel resistances is really as easy as adding the conductances.

You can mentally check the result by realizing that the resistors in parallel will always have less resistance than the smallest of the parallel resistors. In this example, you got 66⅔ ohms, which is less than the smaller of the two resistors (100 ohms).

If you have more than two resistors in parallel, you just add up all of their conductances and divide that into 1 to convert back to ohms.

# 3

# FLASHING, DIMMING, AND OSCILLATING

For many electronic appliances and art pieces, turning the device on or off simply means plugging it in or unplugging it from the wall. Other devices have simple switches, which are not a lot more complicated than plugging into a wall. A switch simply connects two wires together electrically. You can do this by hand for low-voltage things like LEDs. Just touch two wires together and it lights up. You have made a simple switch.

You also know that the brightness of the LED is determined by how much current is flowing through it. And you know you can limit the current using a resistor. This means you know how to dim the lights: just increase the resistance.

You can also replace your current-limiting resistor with a variable resistor. The technical name for a variable resistor is a *potentiometer*. Volume controls on radios and televisions were once simple potentiometers. These days they are more often buttons on a remote control that tell a computer how much to amplify the sound.

Since potentiometers can be set to 0 (no resistance), you will still want to have a fixed resistor to ensure that you don't burn out the LED with too much current. The potentiometer can then be selected to have, for example, 2,000 or 5,000 ohms of resistance when it is at its highest setting (equivalent to the lowest volume on a volume control). The LED will appear to be so dim that it looks like it is off, until you turn up the current by rotating the knob on the potentiometer.

Because the word *potentiometer* has too many syllables, it is often referred to simply as a pot (like the one calling the kettle black).

A potentiometer has three terminals you can solder wires to. The outside terminals are connected to each end of a resistor, just like the ones you used in the LED project. The center terminal connects to a wiper. The wiper is a piece of metal that moves

from one end of the resistor to the other, making a connection to the resistor material. The schematic symbol for the potentiometer shows the wiper as an arrow pointing to the middle of the resistor.

If you ignore the wiper and simply connect the outside terminals of the pot in the circuit, you just have an expensive resistor. But if you connect the wiper and one of the outside terminals, you have a variable resistor, also known as a *rheostat*. When you connect the outside terminals to the two ends of a battery, you have a voltage divider. (Remember the voltage divider discussed earlier?) The wiper then lets you select any voltage, from the highest the battery can deliver to 0, with a convenient twist of the knob.

Sometimes you want something to turn on and off by itself, without someone's hand being involved. You see blinking lights on all kinds of things—they draw your attention, as is their purpose. To make a light blink, you need something that changes over time. That something is an electronic part called a *capacitor*.

A capacitor is a very simple thing. It is two conducting surfaces separated by an insulator. When connected to a voltage source, such as a battery, one surface in the capacitor gets electrons pushed onto it and the other surface gets electrons removed from it. This results in storing electrical energy in the capacitor, very much like charging a battery. That is because when you put an LED in place of the battery, the electrons crowded onto one surface race through the LED to the surface that is deficient in electrons. This lights the LED, until the surfaces are balanced again.

It takes time to charge a capacitor, and it takes time to discharge one. You can change this timing by limiting how fast the electrons can get into and out of the capacitor. You do this with a current-limiting resistor.

The combination of a capacitor and a resistor creates a way of telling time. If you allow the capacitor to charge through the resistor, the voltage between the two surfaces in the capacitor rises until it gets close to the voltage of the battery. It continues to gradually get closer and closer to the battery voltage, but the rate of voltage rise gets slower and slower, exponentially.

In the diagram on the next page, the box on the right is an *oscilloscope*, a device that shows voltages changing over time. It is connected at either end of the capacitor—represented by the new schematic symbol just below the resistor. A battery—the new schematic symbol on the left—provides (in this case) 3 volts.

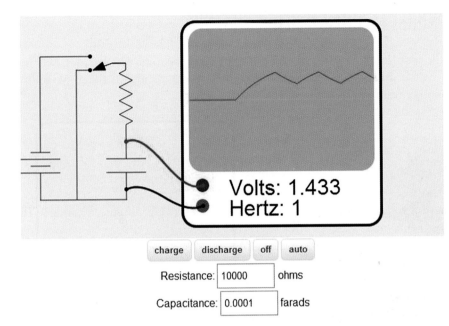

charge | discharge | off | auto

Resistance: 10000 ohms

Capacitance: 0.0001 farads

A switch—the new schematic symbol at the top—can connect the resistor and capacitor to either the top of the battery, giving it power, or the bottom of the battery, shorting it out.

On my website (http://artists.sci-toys.com/flashing), you can click on the Charge and Discharge buttons to watch the capacitor charge or discharge. You can also change the values of the resistor and capacitor.

You can set up a circuit made of transistors that charges a capacitor through a resistor and monitors the voltage level. When the voltage rises to a particular level, the circuit will switch to discharging the capacitor through a resistor until the voltage reaches a second, lower level. At this point, it starts charging again, and the cycle repeats. You now have a circuit that can tick at any rate you desire, simply by making the capacitor bigger or smaller, or making the resistor bigger or smaller, or some combination. This circuit is called a *timer*. In the diagram on the website, clicking on the Auto button simulates a timer.

Timers are so useful in electronics that companies make *integrated circuit chips* that include all of the transistors and other components, all connected for you already, in a little chip. All that remains is to add the capacitor and two resistors, one to charge through and one to discharge through. This lets you set the timing however you desire.

# PROJECT: BUILD A SLOW SWITCH

The simplest timer you can create uses just a capacitor, a resistor, an LED, and a switch. In this project, you will build the second-simplest timer, by adding another resistor.

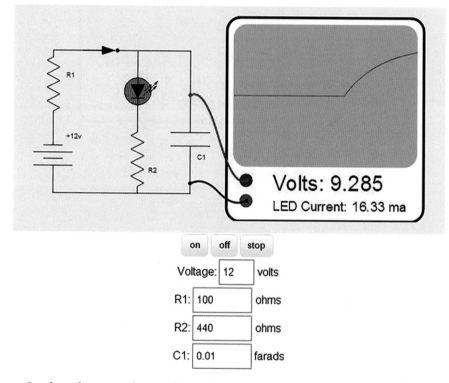

In the schematic shown above (http://artists.sci-toys.com/slowswitch) you can see that there is a resistor near the battery labeled R1. That is the charging resistor, and it determines how fast the capacitor will charge. In the middle you can see the LED and its current-limiting resistor.

When you push the On button, the switch closes and the capacitor begins to charge. The voltage across the LED and its current-limiting resistor is at first not high enough to turn the LED on. The LED is acting as a second (open) switch, keeping any of the current from going through it or its resistor.

At some point, however, the voltage gets high enough (in this case about 1.7 volts) that the LED turns on and current starts to flow through it and through its resistor.

Now the capacitor starts to charge more slowly, since some of the current is being diverted to the LED.

As the voltage on the capacitor rises, the current through the LED increases and it gets brighter. In this simulation, when the LED current exceeds 20 milliamperes, the LED turns yellow, as a warning that the current is higher than the LED is rated for. If the current ever exceeds twice the rated current, the diode turns brown, stops emitting light, and stops allowing current to flow through it. It is now a DED.

After the capacitor has charged for a while, click on the Off button. The battery and its resistor are now disconnected, and the capacitor discharges through the LED and its current-limiting resistor. The size of that resistor not only protects the LED from getting too much current but also determines how long it takes the capacitor to discharge.

What you have built is a slow switch. When you turn it on, the LED slowly gets brighter. When you turn it off, the LED slowly gets dimmer.

Notice that once the LED has stopped glowing, very little current goes through it and the capacitor seems almost to stop discharging. Diodes have a very small conductance (a very high resistance) when the voltage is below their "on" threshold, so the capacitor can only drain very slowly through the unlit LED. Capacitors also have some internal resistance, although it is also very high. It will take a long time for the capacitor to completely drain to zero.

You can play with the values of the resistors and the size of the capacitor to set the timing to your liking. Because the current-limiting resistor for the LED serves two purposes—limiting the LED current and determining the time it takes the LED to fade—you will find that it is simplest to select a value for it first, with the idea of protecting the LED, and then select the size of the capacitor (the other factor that determines the speed at which the LED fades) to set the fade time. When you are happy with the fade time, select the charging resistor to set the charging time.

You can thus have complete control over how long it takes to light the LED fully and how long it takes for it to fade completely.

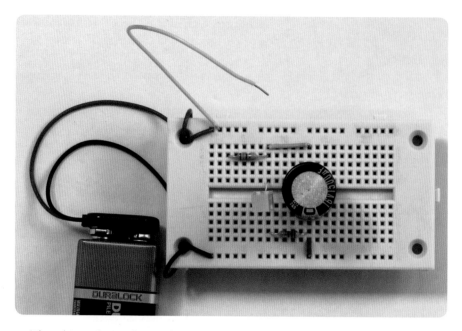

The photo above shows the circuit built on a solderless breadboard. I used a simple homemade switch, just a bit of yellow wire that was plugged into the breadboard to complete the circuit.

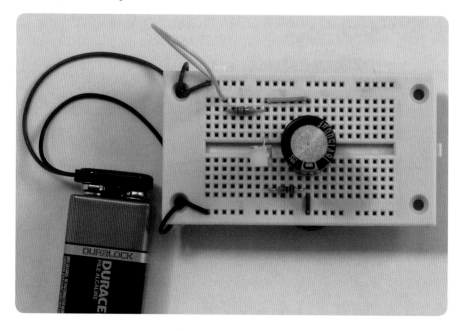

At the bottom of the previous page, you can see the circuit in the "on" state, and below is a diagram showing how the electrons flow through the circuit. Remember, on a board like this the holes in the top and bottom rows are electrically connected to all the other holes in their rows, while each hole in one of the middle columns is electrically connected to the other four holes in its column.

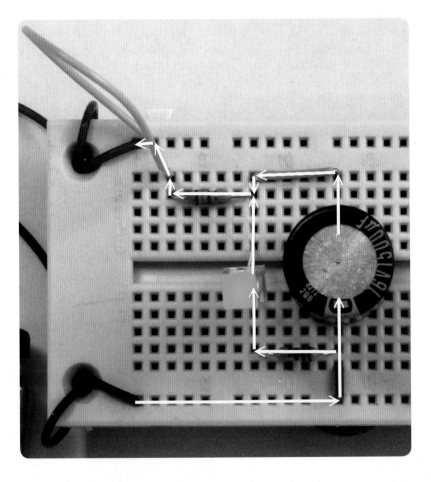

The big round thing on the right is an *aluminum electrolytic capacitor*. You see it here only in the top view, but it is a cylinder about an inch tall.

The LED is easy to spot by the difference between the "off" and "on" photos. It is the green square object.

# PROJECT: FLASHING LEDS WITH AN INTEGRATED CIRCUIT

You now know how to control electrical current with resistors and how to store electrical charge in capacitors. You know how to combine those two parts to create a time delay. You are now ready to use that knowledge in your first project that uses an integrated circuit chip.

The 555 timer chip is a tiny little thing that has several transistors and resistors all connected together inside to make a building block for electronics projects that works like an electrical Lego block. You will combine it with some resistors, a capacitor, and an LED to make the LED turn on and off at any rate you choose.

The 555 is a versatile building block, and it is so handy that over a billion of them are manufactured and sold every year. What it does in this project is fairly simple: it charges an external capacitor through an external resistor until the capacitor reaches two-thirds of the power-supply voltage. Then it flips an internal switch and starts discharging the capacitor through another external resistor until the capacitor reaches one-third of the power-supply voltage. Then the switch flips again and the process repeats, over and over again. This action makes the circuit an oscillator.

The little chip can also be configured to be a timer. In that configuration it simply turns something on or off for a specific time and then returns to its previous state.

Later you will use the chip to change the brightness of an LED and to control motors. But for now, you are going to control how your LED flashes on and off.

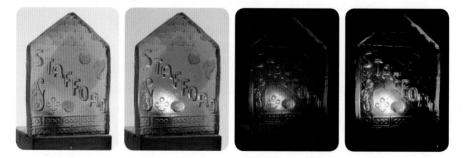

## STUDENT ART PROJECT

In *Our House*, Patrick Stafford controls the brightness of red, green, and blue LEDs to bring a molded glass sculpture to life in millions of colors as the light mixes and each LED dims and brightens.

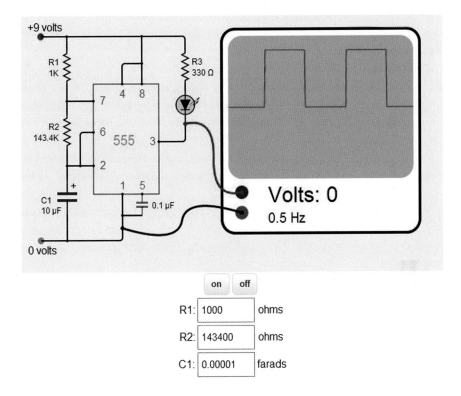

Look for a moment at just the left-hand side of the schematic shown above (http://artists.sci-toys.com/555). Between the positive and negative sides of the power supply, there are two resistors and a capacitor. If the 555 timer chip is not there, the capacitor will charge through the two resistors until it approaches 9 volts.

You know from the earlier discussion of capacitors that this takes some time. That is the key to how this circuit works.

## How It Works

When you first connect the power supply, the LED turns on. This is because pin 3 of the 555 timer starts out at 0 volts—it is connected to the negative side of the power supply by an internal switch. This allows current to flow through the LED and its current-limiting resistor, R3.

As the capacitor charges, the voltage at pin 2 gradually rises.

Pin 2 of the 555 timer is called the *trigger pin*. If the voltage at this pin reaches 6 volts (two-thirds of the power-supply voltage), the chip will use some internal switches to connect pin 3 to the positive power supply (so you see 9 volts on pin 3) and connect pin 7 to the negative power supply, so you see 0 volts on pin 7.

When pin 3 is at 9 volts, the LED turns off, because both sides of the LED have the same voltage and no current flows through anything if both sides are at the same voltage.

Pin 7 of the 555 timer is called the *discharge pin*. When it goes to 0 volts, all the power goes through resistor R1 and almost none of it gets to any of the rest of the circuit. The capacitor not only stops charging but starts discharging through R2 into pin 7. The voltage at pin 2 starts to slowly drop from 6 volts down to 3 volts.

Pin 6 of the 555 timer is called the *threshold pin*. In this circuit you have connected it to the same place as pin 2, so it also monitors the voltage on the capacitor.

When the voltage at pin 6 reaches 3 volts (one-third of the power-supply voltage), the internal switches are reset. Pin 7 is no longer connected to the negative power supply, and pin 3 is. The LED turns back on, and the capacitor starts charging again.

So the whole circuit now oscillates, going from one state to the other and back again. The voltage at the capacitor goes from 6 volts to 3 volts and back again, and the LED turns on, then off, and then back on, over and over.

You may want to take some time to study the preceding description until it makes complete sense to you before we start talking about the rest of the pins on the 555 timer.

## The Other Pins

Pin 1 is connected to the negative side of the power supply. This side is called *ground* in electronics, and in many circuits (like the power to your house), it is actually connected to a big metal spike driven into the dirt on which the house is built. This is why it is called ground. The Earth is so big that it can absorb as many electrons as we can give it, and you can't detect any change in its voltage. It can also deliver as many electrons as a circuit can suck out of it, and still never seem to change voltage. If your house wiring were not electrically connected to the ground, you might get a shock when you touched a lamp or appliance, as the house current would use your body as a conductor to send current into the Earth.

The circuit in this project is probably battery operated, so it doesn't actually need to be connected to the Earth, but the negative side of the battery is still called ground, and that term will be used a lot in the remainder of this book.

Pin 8 of the 555 timer is connected to the positive side of the power supply. This is how the chip gets the power it needs to operate.

Pins 4 and 5 are used to change how the chip operates. In your circuit, pin 4

(the reset pin) is not used, and you connect it to the positive power supply to ensure that it does not change and suddenly reset the timer. Pin 5 is the *control pin* and is also not used in the circuit. You connect it to ground through a small capacitor to ensure that it also stays stable. The small capacitor absorbs any sudden changes in the power supply (these sudden changes are called noise) that might result from other circuits turning on and off. Since there are no other circuits in this simple example, you could actually eliminate the capacitor and leave pin 5 unconnected. But it is a good practice to connect it, just in case.

## Changing the Circuit

Now look at what happens if you change the values of the resistors or the capacitor. If you make the capacitor bigger, it will take longer for it to charge and discharge. The rate at which the LED blinks on and off will get slower. If you make the capacitor smaller, the LED flashes on and off more quickly.

The capacitor charges through both resistors, but it discharges only through R2. This means the LED will always be on longer than it will be off. If you make R2 very large, and R1 very small, this difference will decrease until it is barely noticeable.

But you can't decrease R1 too much or the circuit won't work. Remember that when the capacitor reaches 6 volts, pin 7 goes to 0 and the battery drains directly through R1. If R1 is too small, it will overheat and the battery will not last very long. If the resistance of R1 was 0 (as if it was replaced with a plain wire), all the current from the battery would flow directly from one terminal to the other, in what is called a *short circuit* (the current takes a shorter path than it would if it went through the whole circuit). If that happens, the chip will not get any current and it will stop working. For that reason, don't use less than 1,000 ohms for R1.

If you keep R1 as low as possible, so that the "on" and "off" times are as equal as possible, then the timing is controlled mainly by R2 and the capacitor. Making R2 large means that the capacitor charges and discharges slowly. You can use a large R2 and a small capacitor, or a small R2 and a large capacitor, and get the same timing.

## A New Chip: The 7555

Since the original 555 came out, low-power versions have come out. The low-power version—the 7555—is better for use in battery-powered devices, since it uses less power. The chip itself not only uses less power, but because its trigger and threshold pins are more sensitive, you can use higher value resistors, so less battery current is wasted. Higher resistances allow you to use a smaller (cheaper)

capacitor. The 7555 can also reach higher and lower frequencies. In the 7555, the reset pin usually does not need a capacitor, making the circuit simpler and cheaper.

The potential drawbacks to the 7555 are that it is sensitive to static electricity until it is wired into a circuit, so you have to be careful to discharge your hands before handling it: just touch a large metal object to remove any static electricity from your fingers. The original 555 chip can supply more current (up to 200 milliamperes) to the LED than the 7555 can.

The amount of current the 7555 can provide depends on the power-supply voltage, and on whether the LED (or some other load) is connected to the positive side of the power supply or is connected to ground. If the chip is delivering current through the LED to ground, it is said to be "sourcing" the current. If the LED is connected to the positive side of the power supply, and the current goes through the 7555 to ground, the chip is said to be "sinking" the current.

The 7555 can source only about 2 milliamperes at 5 volts, but it can sink 8 milliamps. At 12 volts things are a little better—it can source 10 milliamps and sink 50. At 15 volts, it can source and sink 100 milliamps.

While this limited current capability might be a problem if you were driving a lot of LEDs, or trying to run a motor, for blinking a single LED, you can use it to your advantage and eliminate the current-limiting resistor for the LED. If the chip can't deliver more than 20 milliamps to the LED, then the resistor is not needed.

Because both the 555 and the 7555 can source current as well as sink current, you can alternately drive two LEDs, each one off while the other is on.

In the circuit on the next page (http://artists.sci-toys.com/changing) you have eliminated the capacitor on pin 5, leaving it unconnected, since the 7555 version of the chip does not need it for this circuit. You also now have two LEDs connected to pin 3 of the chip. One goes to ground, through a 10,000-ohm resistor, and the other goes to the positive power supply through another 10,000-ohm resistor.

Note that you have two LEDs and two resistors making a direct link between power and ground. Without the 7555 chip and the rest of the circuitry, these LEDs would both simply light up. With the 7555 in the circuit, pin 3 alternates

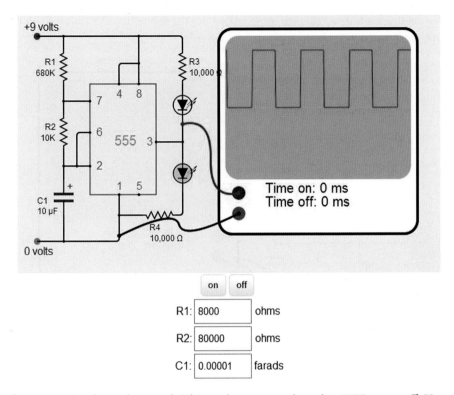

between +9 volts and ground. This makes one or the other LED turn off. You need the high resistor values because the chip can't source or sink very much current, so the current going through the LEDs without the chip in the circuit must be less than the current the chip can source or sink. If you didn't have high value resistors, one or both LEDs would simply stay on.

You may have noticed that the LED takes a while to turn on at first. When the capacitor is completely discharged, as it is when you first apply power, the voltage has to climb all the way from 0 to 6 volts before the top LED turns off. After that, however, it never gets down to 0 volts, since it starts charging again when it gets down to 3 volts. So the first time the LED lights, it stays on longer than on subsequent oscillations.

If you want to keep the "on" and "off" times the same, the 7555 allows you to simplify the circuit (http://artists.sci-toys.com/changing):

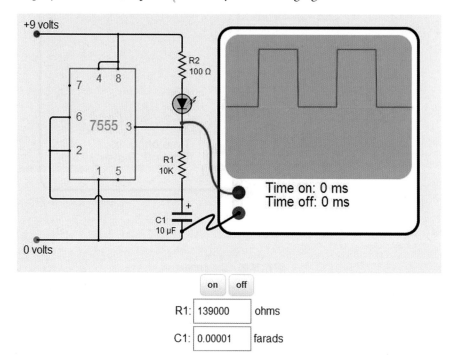

Instead of using the discharge pin (pin 7), you use the output pin (pin 3) to discharge the capacitor. The 7555 can pull pin 3 quite close to 0 volts, acting much like pin 7. So you can leave pin 7 unconnected. You could almost eliminate the current-limiting resistor for the LED, since it will not get enough current to be damaged (the 7555 can't sink as much current as the original 555). But the 7555 isn't strong enough to pull pin 3 down to ground unless there is some resistance between the LED and the positive power supply, so you still need a small resistor.

The result is a simpler circuit, where the frequency of the oscillation is controlled by a single resistor and a single capacitor. And because the capacitor drains through the same resistor that it charges from, the "on" time is the same as the "off" time.

One last note. The schematic shows a connection from pin 2 to the capacitor crossing over the connection between pin 1 and ground. The little bump in the line shows that these two wires are not electrically connected.

If you want the math . . .

The frequency of this last circuit is:

$$\frac{1}{2 \log(2)\ \mathbf{RC}}$$

Since the natural log of 2 is a constant (approximately 0.6931471806), and twice that is also a constant (1.386294361), and the values for the resistor and capacitor are only good to a few percent (so you don't need all that much precision in your constant), you can simplify this to:

$$\frac{1}{1.4\ \mathbf{RC}}$$

For the first circuit, with two resistors, the frequency is

$$\frac{1}{1.4\ (\mathbf{R_1 + 2R_2})\ \mathbf{C}}$$

The "on" time will be 0.7 $(R_1 + R_2)$ C.
The "off" time will be 0.7 $R_2$ C.

# PROJECT: A MORE EFFICIENT LIGHT DIMMER

You explored earlier how to dim an LED using a resistor.

When you put a resistor in series with an LED, the same current flows in the resistor as in the LED. The current that flows in the LED is useful—it goes mostly into providing the light you want. The current that flows in the resistor creates heat. This is a waste of energy if all you want from the circuit is light.

The amount of power lost (dissipated) in the resistor is something you can calculate. The power (in watts) is the current squared, divided by the resistance. Using Ohm's law, you can restate this in the following ways:

**Watts = amperes² × ohms**

**Watts = volts × amperes**

**Watts = volts² ÷ ohms**

In the simple circuit (page 13) where 6.8864 volts causes 32 milliamperes to flow in both the LED and the 215.2-ohm resistor, you lose:

**(0.032 amperes × 0.032 amperes) × 215.2 ohms = 0.2203648 watts**

**0.032 amperes × 6.8864 volts = 0.2203648 watts**

**6.8864 volts × 6.8864 volts ÷ 215.2 ohms = 0.2203648 watts**

You are losing almost a quarter of a watt in the resistor.

## What That Means

Suppose you are powering this earlier simple circuit with a 9-volt battery. The battery can supply 0.565 *ampere-hours* at 9 volts, for a total energy capacity of 5.085 *watt-hours* of energy.

Your circuit draws 32 milliamperes of current, so you would expect the battery to last 17.6562 hours. During those 17 hours, the resistor is dissipating just under a quarter watt of power in the form of heat for each of those 17 hours. That's 17.6562 hours × 0.2203648 watts, or 3.89 watt-hours of power. That's more than three-quarters of the power in the battery, all wasted as heat in the resistor.

## A More Efficient Circuit

Suppose you replace the resistor with some more LEDs. Each LED drops the voltage by 1.754 volts (see the earlier discussion of this circuit, page 10), so five LEDs in series would drop 8.77 volts.

I built the circuit, and here's what I measured. The battery was putting out 9.38 volts. With five LEDs in series, the current was 1.71 milliamperes. The five LEDs were dim.

With four LEDs in series, the voltage dropped to 9.27 volts and the current jumped to 24.7 milliamperes. The LEDs were nicely bright.

Since the amount of light is proportional to the current, you can calculate how much light each circuit produces relative to the other. The LED and resistor had a current of 32 milliamperes. The five LEDs in series had 1.71 × 5, or 8.55 milliamperes producing light. The four LEDs in series had 24.7 × 4, or 98.8 milliamperes producing current. So the four LEDs are producing 3.0875 times as much light as the single LED with its current-limiting resistor while using only 77 percent as much current (24.7 ÷ 32).

The new circuit can run 22.8744 hours on the same battery and put out three times as much light.

## Dimming Using the 555 Chip

With your first circuit, you could dim the LED simply by making the resistor a little bigger. But now you have three times as much light and no resistor to change to control how much light is emitted.

You can steal an idea from movies and television to dim the LED without wasting power as heat. Movies and television flash many frames per second to our eyes, but the flashes are coming so fast that our eyes and brains perceive them as a steady light.

You can use the 555 chip to flash the LEDs so fast that your eyes see them as staying on all the time. But half the time they are off, so they appear half as bright.

The 555 lets you control how long the LEDs are on and how long they are off. So you can vary the brightness from 0 to 100 percent by changing how long

they are on in each brief flash. This method of controlling the brightness is called *pulse width modulation (PWM)*. You are modulating (changing) the width of the pulses to control how much total energy is converted into light by the LEDs.

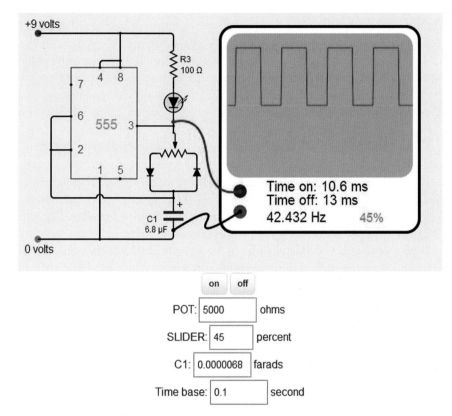

In the schematic diagram shown above (http://artists.sci-toys.com/pwm), the simple circuit has been modified. That previous circuit charged and discharged the capacitor through a single resistor, making the LED blink on for the same amount of time it blinked off. But in this circuit, the resistor has been replaced with a potentiometer and two diodes.

Diodes only conduct electricity in one direction. The two diodes have been arranged so that when the capacitor charges, the electrons flow through the diode on the left. When the capacitor discharges, the electrons flow through the diode on the right.

If you set the slider on the potentiometer all the way to the left (100 percent), then you bypass the resistor altogether and the circuit behaves as if pin 3 were connected to the capacitor directly. Electrons flow from the negative side of the battery (0 volts) through the capacitor, through the diode on the right, and into

pin 3, which is connected inside the 555 chip to the positive side of the battery (+9 volts).

This means the capacitor discharges very quickly. In almost no time at all, pin 6 reaches 3 volts and connects pin 3 to the negative side of the battery instead of the positive side. The LED turns on, since electrons can now flow from pin 3, through the LED, and into the positive side of the battery.

The capacitor now charges, as electrons flow from pin 3, through the potentiometer, and through the diode on the right, filling up the capacitor. But since the electrons have to go through all of the resistance of the potentiometer, it takes a while to fill up the capacitor. So the LED is on for a much longer time than it is off. In fact, it looks like it is always on.

If you set the slider on the potentiometer all the way to the right (0 percent), then the situation is reversed. The LED is off all the time.

In between, you can see that the LED is on for a time that corresponds to the percentage of the potentiometer. Since the total resistance of the potentiometer is always the sum of the two sides, the frequency does not change. The only thing that changes is how long the LED is on in each cycle.

If you set the potentiometer slider to 50 percent, the LED is on for half the time, and if the frequency is high enough, the flashes are so brief and close together that you see the light as continuous but only half as bright as when the LED is on all the time.

What have you gained by using this tricky circuit? You gain battery life. The LED is either fully on or fully off and no power is wasted, since you don't use a current-limiting resistor. You can dim the LED from off to fully on, and almost all of the power the circuit uses is spent making light, not wasted heating up a resistor.

I'd like to make one side note here. You may have noticed that the arrows on the diodes point from positive to negative, the opposite direction that the electrons flow. The choice of which side of the battery to label positive was made before electrons were discovered. It is only an accident of history that the carriers of electric current got labeled negative. But because of that, in electronics we talk about current flow as if positively charged particles were moving from the positive side of the battery to the negative side, when actually electrons move from negative to positive. People talk about conventional current as flowing from positive to negative, but electrons flow from negative to positive. The arrows on the diode symbol reflect this conventional current flow.

The photo above shows the circuit built on a solderless breadboard. I used a 1k-ohm resistor to limit the current for the LED, but smaller values can also be used if you need more light. Below is a close-up of the same photo. You can see the white bands on the two diodes, indicating the direction of current flow. Look at each connection and match it up with the schematic diagram to convince yourself that all of the connections are actually the same, even though the layout looks completely different.

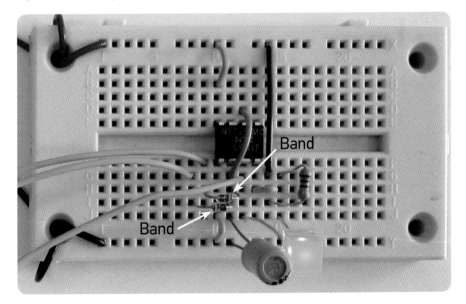

# 4

# CREATING MOTION AND SOUND

In the previous chapter, you saw how to use a 555 timer chip to efficiently dim a light source using pulse width modulation (PWM). In this chapter, you will continue exploring this method of controlling electrical power, but you will use it to control motors, make sounds, and even create your own radio station.

It might seem obvious that if you can control the brightness of an LED, then you should also be able to control the speed of a motor using the same circuit. And it turns out, you can.

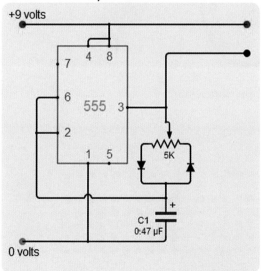

In the circuit shown here, you have replaced the LED and its resistor with plus and minus leads for a motor. You connect the positive side of the power supply directly to the motor, and the negative side of the motor connects to pin 3 of the timer. You do this because the timer can sink more current than it can source. You could have connected the motor to pin 3 and ground, but less current would be available and the motor would not spin as fast.

Below is the circuit built on a solderless breadboard:

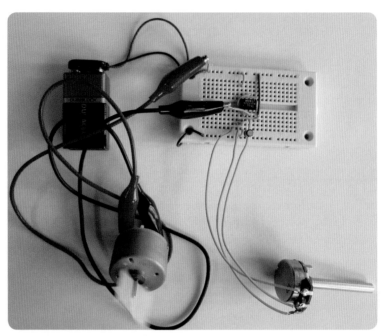

And here is a close-up view of the same circuit:

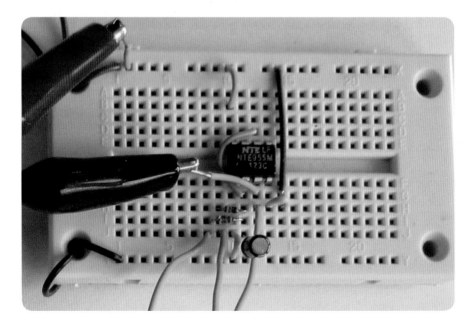

This approach to controlling a motor has some advantages over the simpler and more obvious way, which would be to use a rheostat to vary the current.

A rheostat that can handle the currents involved is a larger, more expensive device than the 555 timer and its circuit components. But also, as you saw with the pulse-width-modulated LED circuit, this way of controlling the motor speed ends up wasting little of the current from the battery. Using a rheostat, most of the battery current would be used heating up the rheostat, and the battery would not last long.

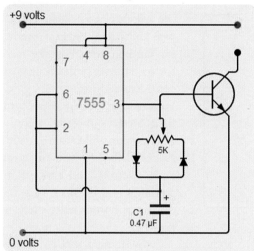

When using the 7555, you have a slight problem. The 7555 can't source or sink as much current as the 555 chip. So you need to add an *NPN transistor switch* to carry the current. The 7555 turns the transistor on and off by setting the base to +9 volts or ground. The transistor then switches the full power supply to the motor on and off in sync with the 7555.

In the photo below, you can see the TIP31 power transistor I used at the upper right of the breadboard. It is driving a small cell phone vibrator motor you can see as a blurry blob vibrating at the end of its connecting wires. The base of the TIP31 NPN power transistor is the leftmost pin. The center pin is the collector, which is connected to the motor. The right pin is the emitter, which is connected to ground.

# PROJECT: CONTROLLING A SERVOMOTOR

In this project you are going to control a special type of motor called a *servomotor*. Servomotors are electric motors that contain electronics in them that read pulses coming in on one of their three wires. The width of those pulses controls the position of the servomotor arm. If the pulses are very short, the arm rotates

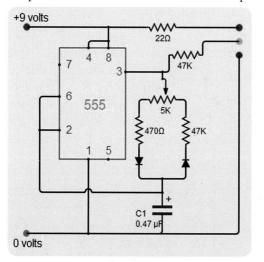

counterclockwise to its limit. If the pulses get a little bit wider, the arm moves a little bit clockwise and stops. The gears in the servomechanism allow the motor to hold its position against considerable force.

Servomotors are used in many devices, most commonly in radio-controlled cars and airplanes. They are used to move flaps, ailerons, and rudders in airplanes, or to steer cars by moving the front wheels left or right.

In the schematic diagram shown above, the by-now-familiar PWM circuit has been modified, but with some extra resistors added.

If the pulse sent to the servomotor is 1 millisecond long, the motor will position its rotor to the extreme left (counterclockwise) position. If the pulse is 2 milliseconds long, the rotor will move to the extreme right (clockwise) position. To center the rotor, send a pulse that is 1.5 milliseconds long.

In between the pulses, the servomotor needs to see about 40 milliseconds of delay. If there is less than 10 milliseconds of delay, the motor will buzz and vibrate. If there is more than about 70 milliseconds, the motor will shut off in between pulses and not hold its position.

This circuit uses a 0.47 microfarad capacitor. The resistance is 52,470 ohms. The formula for the timing is:

$$\frac{1}{1.4\ RC}$$

so you get a frequency of about 30 pulses per second (the pulses are separated by 33 milliseconds). In practice, since capacitor values are only about 20 percent

accurate and resistors about 5 percent accurate, you might get timings that are quite different from those you calculated. In my test circuit, the frequency was closer to 50 pulses per second (a delay of 20 milliseconds between pulses). This is why servomotors allow quite a bit of variance in the timing.

The servo pulse is very short compared with the time between pulses. This allows a transmitter to control many servos, by starting each pulse a little later on a different channel.

You don't want the resistance to go below 470 ohms, so you put a 470-ohm resistor between the potentiometer and the left diode.

Likewise, you don't want the resistance to go above about 52,000 ohms, so you add a 47k-ohm resistor to the 5k-ohm potentiometer's maximum resistance.

These two resistors set the limits of the left and right motion. Now the potentiometer can swing from one end to the other, and the servomotor will match that swing. So now you can twist a knob in one place and watch something rotate in sync with it in a remote place.

Here is what the circuit looks like when built on a solderless breadboard:

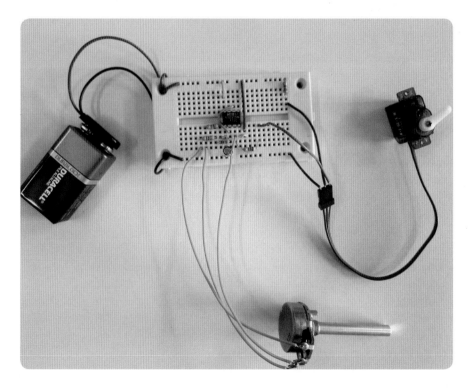

Here is the close-up view of the circuit:

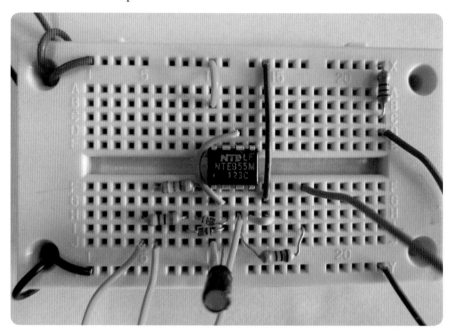

Servomotors have three wires coming out of them. One is for power, the next is ground, and the last one is the control wire, which carries the pulses. The control wire does not need to carry very much current, so you can place a resistor between the output (pin 3) of the timer and the servo. This ensures that the timer operates properly, and reduces the amount of current through it in the case of a short circuit in the motor.

I have also added a 22-ohm resistor between the positive power supply and the servo. This is so the servo does not hog all of the current, so some is left for the timer chip. I could have used two batteries, one for the chip and one for the motor, to give more power to the motor. If the negative side of each battery is connected together, then all circuits connected to the batteries will have a common reference point to measure signals against. When this is done (usually connecting the grounds together), the ground is sometimes referred to as a *common ground*.

Connecting two power supplies using a common ground is also a way to allow the motor to run from a higher voltage than the timer chip.

Servomotor manufacturers have not decided on a standard color coding for the lead wires from the motor, or even a common arrangement for the wires in the connector. The positive wire is usually red, the ground (negative) wire is

brown or black, and the control wire can be yellow, orange, black, or white. You will want to check the proper wiring for whatever servo you are using.

## BEEPS AND SQUEAKS

It is easy to make a 555 timer chip make noise.

Set up the circuit to generate square waves (equal time in the "on" and "off" states), and select your resistor and capacitor so that the oscillations are in the range of human hearing. Then put a speaker on the output.

If the resistor is a rheostat (or a potentiometer with one of the outside wires unused), then you can vary the pitch of the sound. The circuit looks like this in schematic form:

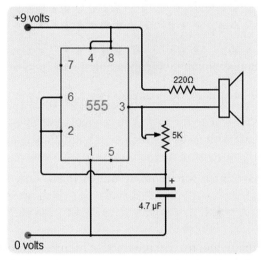

The circuit looks like this when built on a solderless breadboard:

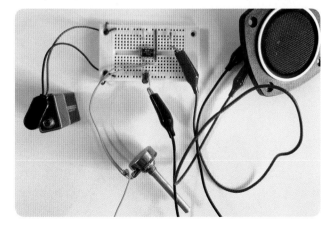

Here is a close-up of the circuit:

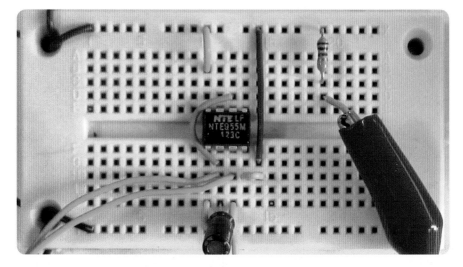

If your project needs to make little blips or beeps when buttons are pushed, then this little circuit will do the trick. You can replace the potentiometer with a row of resistors, each with its own switch, and build a toy piano. The noises are reminiscent of early video games, which also used square waves sent to a speaker.

# 5

# COMPUTER-CONTROLLED LEDS

You've done some fairly simple things with basic electronics up to this point. You can do much more complicated things, still using integrated circuits and other parts, but the circuits get much more complicated and difficult to put together.

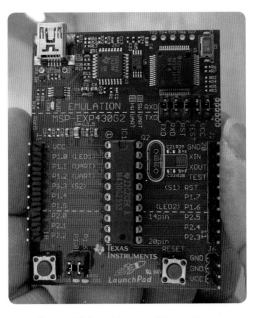

To keep things simple, and yet get all of the flexibility and creative power you want, you will use a computer. Unlike other computers you may have used in the past, however, this one is the size of a credit card and costs less than $10. Later on, it will get even smaller and cheaper, using just the computer chip itself instead of the entire circuit board. Eventually you'll be able to add intelligence to your artwork for about a dollar.

Pictured above is the Texas Instruments MSP430 LaunchPad. For $9.99, you actually get three computer chips. There is one soldered onto the board at the top right. That is the computer that controls the board, talks to other computers, and programs the second computer chip, the one in the socket in the center of the board. That second chip will run the programs you create. Those programs will blink LEDs, control motors, and sense the world. In addition, there is a third computer chip in the package (not shown) that you can also program and use in your projects.

The computer board has some LEDs and switches on the board already, so you can start writing programs and testing them without having to build anything. But the board also has pins that allow you to connect the computer chip

to external LEDs, motors, switches, and sensors. In later projects, you will remove the computer chip from this board after you program it, and place the computer chip in your own circuit, where it can control things all by itself.

## TOOLS FOR PROGRAMMING

This little computer has no keyboard and no screen. To program it, you will use a more familiar form of computer: your desktop or laptop computer.

While Texas Instruments provides a free complete professional software toolkit for programming the LaunchPad, you will use a simpler program called Energia. It installs easily and simplifies the process of writing and running programs for the LaunchPad. Energia is also free.

You can find Energia here: https://github.com/energia/Energia/wiki /Getting-Started.

On that page there are instructions for downloading and installing it on Windows, Mac, and Linux operating systems.

Once Energia has been installed on your machine, running the Energia program will bring up a window like the one to the left. By copying the program below (available online at http:// artists.sci-toys.com/programming _tools) into the empty Energia window, you can run your first program.

```
void
setup()
{
    pinMode( RED_LED, OUTPUT );
}

void
loop()
{
    digitalWrite( RED_LED, HIGH );    // Turn the LED on
    delay( 100 );                     // Wait for a tenth of a second
    digitalWrite( RED_LED, LOW );     // Turn the LED off
    delay( 100 );                     // Wait for another tenth of a second
}
```

After pasting the program into the window, you can Save As using the name "flash_led." The window will now look like this:

At the top of the window are five button icons. One has a checkmark. That button will cause Energia to check the program for errors. The next button has an arrow. That button will send the program to the LaunchPad computer and start that program running.

Before you can run your program, you first need to connect the computer running Energia to your little LaunchPad computer. This is easy—simply plug one end of a USB cable into the LaunchPad and the other end into the big computer. Since you loaded the drivers for the LaunchPad when you installed Energia, your computer knows how to communicate with the little LaunchPad computer.

There are only two things left to do to make your program work. First, tell Energia which board you are using. The Tools menu has a Board item. You are using the "msp430g2553" board (because there's an MSP430G2553 chip in the LaunchPad):

Next, tell Energia which communications port the LaunchPad is connected to. It is probably the last port on the list in the Tools menu Serial Port menu item. If it isn't, Energia will complain and you can try the others in turn:

Now, at last, you can click on the Energia button that has the little arrow on it. That will send your program to the LaunchPad and start it running. You should see the red LED on the board start to flash.

## YOUR FIRST PROGRAM

Your first program looks like this:

```
flash_led | Energia 0101E0009

File  Edit  Sketch  Tools  Help

flash_led §

void
setup()
{
    pinMode( RED_LED, OUTPUT );
}

void
loop()
{
    digitalWrite( RED_LED, HIGH );      // Turn the LED on
    delay( 100 );                       // Wait for a tenth of a second
    digitalWrite( RED_LED, LOW );       // Turn the LED off
    delay( 100 );                       // Wait for another tenth of a second
}

Done uploading.
Erasing...
Programming...
Done, 590 bytes total

13                              LaunchPad w/ msp430g2553 (16MHz) on COM10
```

There are two functions, called setup() and loop(). All of the Energia programs will have these two functions. The setup() function is run once. Then the loop() function is run over and over again, forever.

In this first program, you have a single line of code in the setup() function.

Computer chips like the one in your LaunchPad have a number of little metal legs coming out of the plastic block that hold the chip. These legs are called pins,

and they can be set to either listen to the outside world or speak to the outside world. Listening is called INPUT, and speaking is called OUTPUT. Since you want to make an LED flash, you are speaking, so set the mode of the pin that is connected to the red LED on the board to OUTPUT.

That is what the line

```
pinMode( RED_LED, OUTPUT );
```

does in the setup() function.

In the loop() function, you turn the LED on by setting that pin to HIGH, using the digitalWrite() function.

Your little LaunchPad computer is very fast. It can run millions of lines of code every second. If you simply turned the LED off again right away, it would not appear to flash, because your eye can't detect flashes that happen millions of times per second. So you need to add a delay between turning the LED off and back on again.

The delay() function simply waits until some number of milliseconds have elapsed. A millisecond is $\frac{1}{1000}$ of a second, so 100 of them is $\frac{1}{10}$ of a second. If you delay for $\frac{1}{10}$ of a second after the LED comes on, and another $\frac{1}{10}$ of a second after it turns off, you will get five flashes per second. Your eyes can easily detect that.

## NUMBERS AND CONSTANTS

In your first program, you used the words RED_LED, OUTPUT, HIGH, and LOW.

These words are actually synonyms for numbers. The word HIGH is a synonym for 1, and LOW is a synonym for 0.

The word OUTPUT is a synonym for 1, and INPUT is a synonym for 0.

The word RED_LED is a synonym for 2. The word GREEN_LED is a synonym for 14.

You use these synonyms so you don't have to remember that the red LED on your LaunchPad computer is connected to pin 2 and the green LED is connected to pin 14.

You can change your first program to use the green LED instead of the red one:

Simply change all three references to RED into references to GREEN and then click on the button with the arrow. Now the green LED will flash instead of the red one.

Your program also contains comments, so that the reader will understand what is going on. Comments start with two forward slashes, and Energia colors

thcm green. The comments are just to help people read the code. The computer does not need them and doesn't even really look at them, other than to skip over them to get to the next line of code.

Without comments and helpful synonyms, your code would look pretty bare and cryptic:

. . . but it would still do the same thing: blink the green LED five times per second.

## PORTS

You can make both onboard LEDs flash if you like:

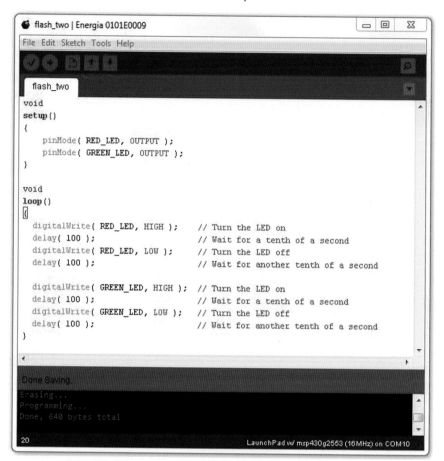

First the red light flashes, then the green, and then it repeats.

If you wanted to control a larger number of LEDs, your program would get rather large. You can trim it down a bit by remembering that the names RED_LED and GREEN_LED are just synonyms for numbers.

If you look carefully at the LaunchPad board, you will see that the pins are labeled. One of them is labeled P1.0 (LED1). That tells you that the pin is one of two *ports* (collections of bits connected to pins) called P1 and P2. Port 1 (P1) has eight bits, and LED1 (the red LED) is connected to the first one, bit 0. You can see the other seven bits on the board, and the eight bits on port 2 (P2) (bits 6 and 7 of port 2 are labeled XIN and XOUT). P1.6 has the additional label (LED2), showing you that the second LED (the green one) is connected to that port bit.

You can write to all of the bits in a port with a single instruction. Here is a simple program (http://artists.sci-toys.com/led _count.txt) that counts from 0 to 255, over and over, on port 1:

In the setup() function, you make all of the bits output bits. In your earlier programs, you did this one pin at a time, using the

```
pinMode( RED_LED, OUTPUT );
```

function. Remember, OUTPUT was a synonym for 1.

In this new program, you set all eight bits on port 1 to be in the output direction by making a number that has eight binary bits all set to 1. That is what 0b11111111 means—0b is for binary, and there are eight 1 bits after it. The P1DIR is the name of the place in the LaunchPad that controls the direction (INPUT or OUTPUT) of port 1.

Next, the setup() function sets all eight of the port 1 output bits to 0. You don't need to say 0b00000000, because that is the same as 0.

In the loop() function, you add 1 to whatever number is in P1OUT. P1OUT is 0 at first, so after you increment it (that's what the "++" does—it adds 1 to something), it will be 1, and the LED connected to port 1, bit 0 will turn on.

The LaunchPad only has two LEDs on the board. But you can attach jumper wires from the LaunchPad to a solderless breadboard and put eight LEDs there. Run the jumper from each of the P1 port bits to the breadboard, and also run a jumper from the GND pin to the breadboard, so the circuit will be complete.

Your little computer is so fast it can count to 255 in less than the blink of an eye. You must put a half-second delay in the loop() function so you can see it count. If you didn't, all of the lights would look like they were on at once, even though they were actually flashing millions of times per second.

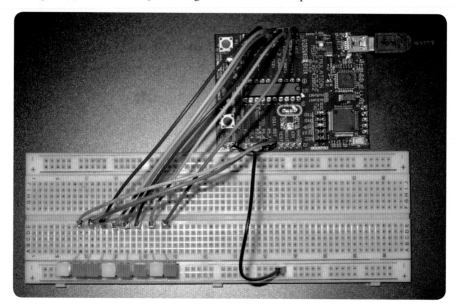

In the photo on the previous page, you can see it has captured the image just as the LaunchPad has counted to the number 0b10010010, which is the same as the number 146. Each LED represents one power of 2. You can see that bit 7, bit 4, and bit 1 are turned on; 27 is 128, 24 is 16, and 21 is 2. Adding them up, you get 128 + 16 + 2, which is 146. (If counting in binary seems tedious, don't worry. The computer will do it all for you.)

When programming the LaunchPad, you will be referencing the inputs or outputs sometimes by their pin numbers and sometimes by their port number and bit number. There are 20 pins on the chip, and eight of those are connected to port 1, and another eight of them are connected to port 2.

Don't get confused with the two ways to talk about the same wire connected to the LED. Some commands (like pinMode and digitalWrite) deal with pins, and they number the pins from 1 to 20. This is a holdover from the Arduino system that Energia is emulating on the LaunchPad. The Arduino is an older system, and it numbered its pins instead of having nice labels like the Launch-Pad has.

Here is the mapping table to convert port and bit numbers to pin numbers:

| Pin 1 | | Pin 11 | Port 2 Bit 3 |
|---|---|---|---|
| Pin 2 | **Port 1 Bit 0** | Pin 12 | Port 2 Bit 4 |
| Pin 3 | **Port 1 Bit 1** | Pin 13 | Port 2 Bit 5 |
| Pin 4 | **Port 1 Bit 2** | Pin 14 | **Port 1 Bit 6** |
| Pin 5 | **Port 1 Bit 3** | Pin 15 | **Port 1 Bit 7** |
| Pin 6 | **Port 1 Bit 4** | Pin 16 | |
| Pin 7 | **Port 1 Bit 5** | Pin 17 | |
| Pin 8 | Port 2 Bit 0 | Pin 18 | Port 2 Bit 7 |
| Pin 9 | Port 2 Bit 1 | Pin 19 | Port 2 Bit 6 |
| Pin 10 | Port 2 Bit 2 | Pin 20 | |

I suggest you always use the port numbering system (i.e., P1.4 to mean bit 4 on port 1) instead of pin numbers.

## PATTERNS

Counting in binary on the lights makes pretty patterns, but you can do more:

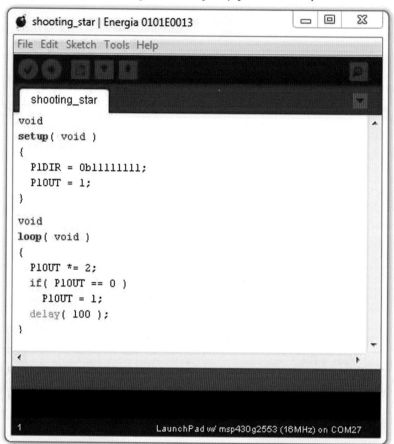

This program (http://artists.sci-toys.com/shooting_star.txt) lights the LEDs one at a time, from right to left, and then starts over.

The line

```
P1OUT *= 2;
```

means "multiply P1OUT by two." If you do that eight times, the number will be 256, which is too big to fit in eight bits. All of the eight bits become 0 when that happens. If P1OUT is 0, you set it to 1, so the pattern repeats. You only delay by 1/10 of a second, so the light seems to shoot across the LEDs like a theater marquee —see http://artists.sci-toys.com/sites/default/files/animated_shooting_star.gif:

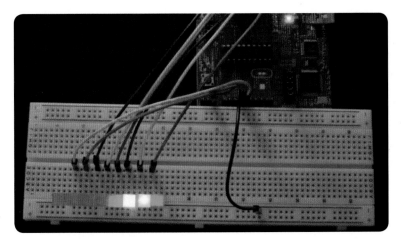

In writing computer programs, there are usually many different ways to do the same thing. Here is the shooting star program (http://artists.sci-toys.com /shift_star.txt) using some new concepts:

```
int star = 1;
int x = 0;

void
setup()
{
  P1DIR = 0b1111111111;
}

void
loop()
{
  P1OUT = star << x;
  x %= 8;
  delay(100);
}
```

The first new concept is how to make up new variables. You have two integers declared at the top: Star and X. Star is the bit that will travel along the lights. X is a counter, which will simply increase incrementally each time through the loop.

The next concept is shifting. You can shift all of the bits in a number left or right, using the << and >> operators. In this case, you are shifting the 1 bit to the left. That has the same effect as multiplying by two if you only shift one bit at a time. But you can shift by a number—in this case, the number in the variable X. If you shift the 1 bit seven times, the light is now at the left end of the string of LEDs.

The last new concept is the *modulo operator*, the %= in the line x %= 8;. It gives the remainder after dividing by something (in this case by 8). This is a tricky way of making sure that when X gets bigger than 7, it becomes 0 again. This is the "clock arithmetic" you learned in fourth grade.

Now you can get tricky. How about a train of five lights moving right to left (http://artists.sci-toys.com/train.txt)?

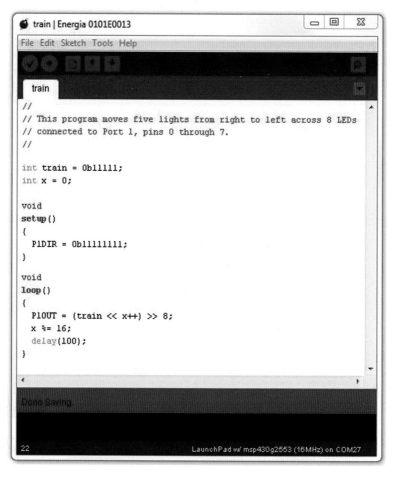

See if you can figure out how that program produces this pattern in the lights: http://artists.sci-toys.com/sites/default/files/train_animation.gif.

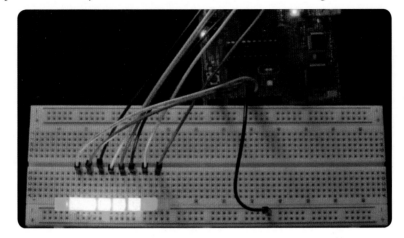

The tricky part is the line

```
P1OUT = (train << x++) >> 8;
```

Here you shift the train of five bits to the left by whatever number is in X (it will be between 0 and 15). Then you shift it to the right by eight, all in the same line.

## STUDENT ART PROJECT

In *Vortex* by Patrick Stafford, a "comet" program running on a LaunchPad makes the LEDs behind the fiber optics seem to chase around the vortex, slowly fading in sequence before the next comet comes around.

You can make the train start out moving quickly and slow down as it gets to the end:

You can make the train go the other direction by changing one line:

```
P1OUT = (train << (16-x++)) >> 8;
```

You can also make a longer train (http://artists.sci-toys.com/long_train.txt) by adding six bits from the second port, port 2:

```
long_train | Energia 0101E0013                          [_] [□] [✕]

File  Edit  Sketch  Tools  Help

[toolbar icons]

 long_train

//
// This program moves five lights at a time from left to right, like a train.
// The LEDs are connected to all the pins in Port 1 (pins 0 through 7) and
// Port 2 (pins 0 through 5).
//

long int train = 0b11111;
int train_length = 5;
int how_many_p1_lights = 8;
int how_many_p2_lights = 6;
int x = 0;

void
setup()
{
  P1DIR = 0b11111111;
  P2DIR = 0b111111;
}

void
loop()
{
  P1OUT = (train << x) >> train_length;
  P2OUT = (train << x) >> (train_length + how_many_p1_lights);
  x++;
  x %= (train_length + how_many_p1_lights + how_many_p2_lights);
  delay( 1000 );
}
```

```
Done Saving

29                              LaunchPad w/ msp430g2553 (16MHz) on COM27
```

In the program above, the constants have been replaced with variables whose names tell you what the magic numbers represent. This is handy not only for reading the program but also for making changes easily if needed.

The photo above shows the long train (14 LEDs) and the connections to the second port on the LaunchPad: http://artists.sci-toys.com/sites/default/files /long_train.gif.

## DIMMING

In your programs so far, you have been simply turning the LEDs on and off.

But as you saw when you were playing with LEDs and chips earlier, you can use pulse width modulation to control the brightness of the LED so you can make it brighter or dimmer as you please.

With the computer, you have several advantages over the 555 timer chip. For one, you can control 16 LEDs at once. (I only used eight in this next program, but port 2 is also available.)

The program on the next page (http://artists.sci-toys.com/pwm_led.txt) loops 256 times, and the first LED is only on for two of those cycles, so it is less than 1 percent on. The next LED is on for 4 cycles out of 256, or about 1.5 percent on. By the time you get to LED 6, the LED is on for 50 percent of the time.

pwm_led | Energia 0101E0013

File  Edit  Sketch  Tools  Help

pwm_led

```
//
// This program controls the brightness of 8 LEDs, each one a little brighter than the last.
//

void
setup()
{
  P1DIR = 0b11111111;
}

void
loop()
{

  for( int x = 0; x < 256; x++ )
  {
    P1OUT = 0;
    if( x < 2 )
      P1OUT |= 1;
    if( x < 4 )
      P1OUT |= 2;
    if( x < 8 )
      P1OUT |= 4;
    if( x < 32 )
      P1OUT |= 8;
    if( x < 64 )
      P1OUT |= 16;
    if( x < 128 )
      P1OUT |= 32;
    if( x < 160 )
      P1OUT |= 64;
    if( x < 240 )
      P1OUT |= 128;
  }
}
```

Done Saving.

36                                                        LaunchPad w/ msp430g2553 (16MHz) on COM27

## Hardware Pulse Width Modulation

You don't have to rely on software to do pulse width modulation. The chip in the LaunchPad has three built-in timers that can be connected to some of the pins, and those timers can do all the work for you, if you are willing to live with the limitation that only some pins can be used.

Unfortunately, these limitations make discussing hardware pulse width modulation on the LaunchPad look quite complicated, and make the analogWrite() function behave in a funny way. To keep things simple for now, the complicated stuff will be left for the next section (page 82), which you are free to skip over.

The program on the next page shows you the simple way to use hardware pulse width modulation (http://artists.sci-toys.com/simple_hardware_dimming .txt), which is simply to pretend that the LaunchPad can only change the brightness of three LEDs. These are the port 1 bit 2, port 2 bit 1, and port 2 bit 4. These are connected to pins 4, 9, and 12.

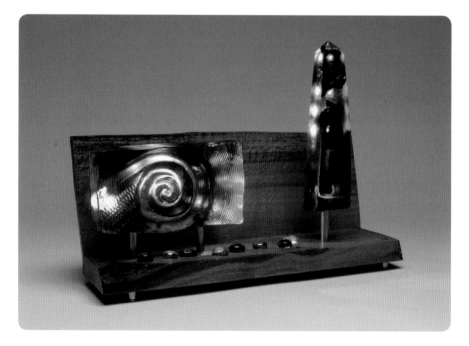

## STUDENT ART PROJECT

The glass sculpture *Spiral and Obelisk* by Patrick Stafford takes on new dimensions when lit by computer-controlled LEDs.

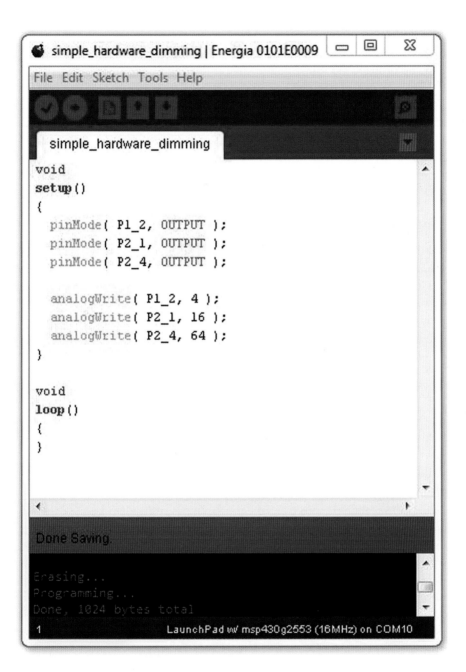

The program shown above sets the brightness on three LEDs to low, medium, and bright (levels 4, 16, and 64). Note that since the hardware is doing all the work, all you do is set up the levels in the setup() function. There is nothing

you need to do in the loop() function, so you leave it empty. Of course, in a more useful program, you might have something interesting happen there, and it would probably do something to change the brightness of the LEDs.

Since you can control the brightness of three LEDs at once, you can make an *RGB LED* look like any color you wish. An RGB LED is actually three LEDs in the same device—a red one, a green one, and a blue one (hence the name RGB). When these colors are mixed, they can create all the colors of the rainbow. Turning them all on at once makes white. Turning red and green on makes yellow. Turning the LEDs on at different brightnesses gives you all of the colors in between.

## Limitations of Hardware PWM

The pins that can do hardware pulse width modulation are pins 4, 9, 10, 12, 13, 14, and 19. These are the pins that are connected to bits 2 and 6 on port 1 and bits 1, 2, 4, and 6 on port 2.

This can get a bit confusing, with the two names for each being LED. Fortunately, there are convenient names for the pin numbers that map them back to the ports and bits. Instead of saying

```
analogWrite( 4, 20 );
```

you can say

```
analogWrite( P1_2, 20 );
```

so you can think in terms of port 1 bit 2 instead of trying to remember which pin is connected to that bit (in programs, we have to use underscores instead of periods to separate the pin from the port). This is convenient because the pins on the board are not numbered, but they are labeled with the port number and the bit number. So instead of counting, you can just connect the wire to the pin with the right label.

Hardware pulse width modulation is done using timers inside the computer chip. The chip has three timers, so only three different brightness levels can be controlled at once.

The timers are limited as to which pins they can control. The first timer can control P1.2, P1.6, and P2.6. If you have three LEDs, one connected to each of those pins, respectively, then they will all be under the control of the same timer. This makes analogWrite() do an unexpected thing: writing to either pin changes all three of them.

The same goes for the second timer, which connects to P2.1 and P2.2. The analogWrite() to either one controls both at the same time.

The third timer connects to P2.4 and P2.5, and analogWrite() to either changes both.

Only analogWrite() has this problem, because digitalWrite() doesn't use the timers, so it can control one LED at a time just fine.

## CONTROLLING 120-VOLT LAMPS

Sometimes you just need more light.

Your little computer runs on 3.3 volts. Worse, it can't deliver more than a few milliamperes of current. It can light an LED but not a lot more. However, if you are very close to an LED, the difference between off and on is like day and night.

You can take advantage of that day-and-night difference. At your local hardware store, you can buy a lamp controller that turns a lamp on at dusk and off at dawn. It knows the difference between day and night. With your LED and a bit of vinyl tape, you can fool it into turning on and off whenever you wish.

You can find the type that has screw-on connectors (known as Edison sockets) or the plug-in type.

Constructing your first prototype is quick and easy. Start by soldering some long wires to your LED so the computer doesn't have to be right there at the lamp.

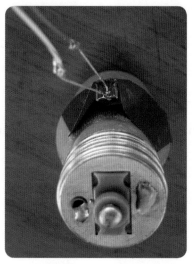

Then use some vinyl electrician's tape to attach the LED right over the hole where the device senses light. I used a square LED, but a round one would have made the job a little easier, as it would have fit into the hole.

Finally, cover the LED with enough tape to prevent outside light from reaching the photoresistor in the little hole.

When the controller is screwed into a lamp socket, and a bulb screwed into the controller, you are finished.

Any of the programs you used to blink an LED will now be able to turn the lightbulb on or off. Because the LED looks like daylight to the controller, turning the LED on will turn the lamp off, and turning the LED off will turn the lamp on.

The vinyl tape is not a permanent way to attach the LED. Black epoxy would make a much better attachment, or some PVC glue, followed by some black paint after the glue is dry. But for this quick demonstration, the tape will do just fine.

You can even dim the light, after a fashion. The cheap little controller doesn't react to light fast enough to do a perfect job, so there is a little flickering, like a candle flame. Also, you don't get the full range of your analogWrite() function, as values less than about 70 stay on and values above 150 stay off. But you can actually use pulse width modulation to get some values between all the way on and all the way off, which is pretty good for a couple bucks and five minutes worth of effort (http://artists.sci-toys.com/DimBulb.txt).

```
//
// DimBulb is a class that controls a light bulb connected to a photoelectric socket
// that normally just turns the light on at dusk and off at dawn. By taping an LED over
// the photosensor, you can use it to dim the bulb by computer control.
//
// The photoelectric socket I used was sensitive to levels between about 70 and 150. Other
// values simply left it on or off.
//
// Unfortunately, the photoelectric sockets I have found do not respond quickly enough
// to make a nicely dimmed bulb -- they flicker a bit. So this mechanism is more suited to
// simply turning bulbs on and off. The good news is that you can control 16 bulbs using
```

```
// digitalWrite instead of analogWrite, giving you 16 levels of brightness just by
// controlling how many bulbs are on.
//
// To smoothly Pulse Width Modulate a light bulb, use this program but connect the computer
// to a solid state relay instead of using the photoelectric socket and LED trick.
//

class DimBulb
{
  int pin;
public:
  DimBulb( int p ) { pin = p; pinMode( pin, OUTPUT ); }
  void level( int l )
  {
    analogWrite( pin, l );
  }
};

DimBulb a( 4 );

void
setup()
{
}

void
loop()
{
  for( int x = 70; x < 150; x++ )
  {
    a.level( x );
    delay( 50 );
  }

  for( int x = 150; x > 70; x-- )
  {
    a.level( x );
    delay( 50 );
  }
}
```

# PROJECT: METRONOME

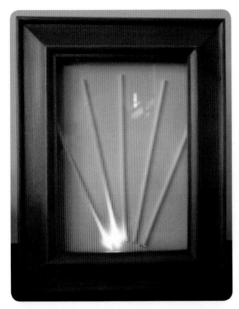

In this project, you will build a metronome out of LEDs, soda straws, a tiny speaker, and the LaunchPad computer.

The LEDs in this case are small—3 millimeters in diameter—and so you must use straws that are also narrow, and just barely fit over the LEDs. The white plastic straw guides the light and glows like a red wand. In this way you can simulate the pendulum of the metronome by sequentially turning the LEDs on one after another so they appear to wave back and forth. At each end of the wave, the speaker gives a little click, to count the time.

Start with the LED and the straw. Bend the legs of the LED at a right angle.

To hold the LEDs and the straws in the right places, mount them on a bit of foam-core board. The legs of the LED can simply be pushed through the board, and the straw is pushed onto the LED.

A dab of glue holds the straw in place. The leads of the five LEDs are bent on the back of the foam-core board. The long leads are all soldered together. They will connect to the ground pin on the computer. Each of the other leads is given a wire that leads to one of the output pins of the computer.

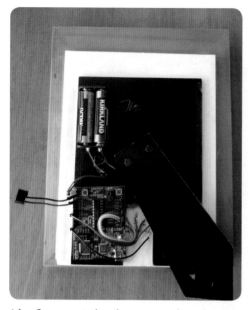

Put the foam core behind the glass of a small picture frame and attach the battery holder and the computer using double-stick tape.

The speaker is the little black cylinder connected to P2.3 and one of the ground pins. The VCC pin and the other ground pin are connected to the battery. (VCC is the computer term for the positive side of the power supply.)

The program for the metronome is here: http://artists.sci-toys.com/metronome.txt.

The main complexity in the code is how the speed of the metronome is set. Use the second push button (the first one is hard-connected to the computer's reset pin, so you can't use it). Tapping the button like a drum is how you set the metronome speed. Wait for eight taps of the button, and save the time between the taps in memory. Throw out the first one, since people usually take a second to get the timing right when they start drumming.

Using the average time between taps, then use that as the time between clicks on the metronome.

Make the clicks by simply sending a 1 bit to the speaker for a millisecond.

The LEDs are connected to unused pins on port 1. Pins 0 and 6 are used for the onboard LEDs, which you use to give the user feedback when setting the timing. Pin 3 is connected to the button. That leaves P1.1, P1.2, P1.4, P1.5, and P1.7 available for the LEDs of the pendulum. Since they are not all contiguous, don't use fancy bit-twiddling tricks, simply have an array of values to send to port 1.

## SERIAL CONTROL OF 14 DIMMABLE LEDS

Serial communication on the LaunchPad uses two of the pins (P1.1 and P1.2, the ones labeled UART on the board).

You can use the serial port to control the remaining 14 pins, sending characters to the LaunchPad to change the brightness of the LEDs you attach to those pins. You use software pulse width modulation so you are not limited to three pins, as you would be if you used the timers to do the PWM.

The program for doing 14-pin PWM controlled by the serial port (http://artists.sci-toys.com/serial_pwm.txt) is shown below:

```
unsigned short values[16];
unsigned short limits[16];

enum { RESOLUTION=512 };

void
setup( void )
{
  P1DIR = 0b11111111;
  P2DIR = 0b11111111;

  Serial.begin( 9600 );

  for( unsigned x = 0; x < 16; x++ )
    limits[x] = x * x + 1;
}

char cmd[4];
unsigned in = 0;

int
digit( char c )
{
  if( c >= '0' && c <= '9' )
    return c - '0';
  else if( c >= 'A' && c <= 'F' )
    return 10 + c - 'A';
  else if( c >= 'a' && c <= 'f' )
    return 10 + c - 'a';
  else
    return -1;
}

void
tick( void )
{
  for( unsigned x = 0; x < 8; x++ )
```

```
  {
    if( values[x] == limits[x] )
      P1OUT &= ~(1 << x);                    // pin goes low
    else if( values[x] == 0 )
      P1OUT |= 1 << x;                       // pin goes high

    values[x]++;
    if( values[x] > RESOLUTION )
      values[x] = 0;
  }

  for( unsigned x = 0; x < 8; x++ )
  {
    if( values[x+8] == limits[x+8] )
      P2OUT &= ~(1 << x);                    // pin goes low
    else if( values[x+8] == 0 )
      P2OUT |= 1 << x;                       // pin goes high

    values[x+8]++;
    if( values[x+8] > RESOLUTION )
      values[x+8] = 0;
  }
}

void
loop( void )
{
  if( Serial.available() )
  {
    char c = Serial.read();
    if( digit( c ) < 0 )
    {
      in = 0;
      return;
    }
    cmd[in++] = c;
    if( in == 3 )
    {
      in = 0;
      int pin = digit( cmd[0] );
```

```
    if( pin >= 0 && pin <= 15 )
    {
      unsigned val = (16 * digit( cmd[1] ) + digit( cmd[2] ) ) % RESOLUTION;
      limits[pin] = val;
    }
    else
    {
      in = 0;
    }
  }
}

  tick();
}
```

The setup() function sets all 16 pins to be outputs. Then it calls Serial.begin ( 9600 ) to set one of the pins to input and to set the speed of the serial connection to the host computer. Finally, it sets the initial PWM values to an ascending sequence, so the lights get brighter as you move up the pin numbers. That last part is optional—you could simply let all the LEDs start out dark.

The digit() function simply takes in a character in set 0123456789ABCDEF and returns a number from 0 to 15. If the character is not in the set, digit() returns the value –1.

The tick() function is the one that does the pulse width modulation of the pins. For simplicity, modulate all 16 pins. The Serial class will make certain that you don't interfere with its use of the UART pins.

The tick() function uses two arrays: values and limits. It uses the values array to count how many ticks a pin has been high. It uses the limits array to tell when to set that pin low. The value RESOLUTION determines how many ticks there are before it starts a new cycle. If you want to control all 16 LEDs in a program that does not use the serial port, just take out the serial port lines from setup() and loop() and the program can modulate all 16 pins.

The loop() function checks to see if there is a character waiting to be read. If so, it reads it. If the character is not in your set, ignore it and return.

The first character says which LED (out of 16, not 14) to change the brightness of. The next two characters tell you how bright to make it. The three characters are sent in hexadecimal, which is both faster and easier for the computer to decode than normal decimal numbers.

If you send the LaunchPad the sequence 580, the program will set the LED on P1.5 to half brightness (80 in hexadecimal is 128 decimal, which is halfway

to 256, the highest number you can encode in two hexadecimal digits). To turn that LED off, you would send the sequence 500. To make it as bright as you can, send the sequence 5FF. That is actually setting the LED to be on half the time, since your program has a resolution of 512. If you want to allow the LEDs to go to full brightness, you should change RESOLUTION to 256. I use 512 because your eyes can't tell the difference between the brightness levels when they are very bright.

Of course, if you can control LED brightness, you can also control motor speed or servomotor position, as you will see in the next chapter.

# PROJECT: RANDOMLY TWINKLING LEDS

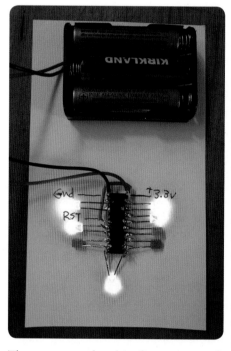

In this short project, you are going to use the MSP430G2452 chip that comes in the box with the LaunchPad. You are going to turn it upside down and solder things directly to the legs of the chip. This is referred to as "dead bug" construction and is a way to get small simple projects done quickly. It is also referred to as "ugly construction" for reasons you can see in the photos.

I glued the chip to a 3 × 5 index card and marked the power, ground, and reset pins, since it is easy to get confused as to which pin is which when the chip is upside down.

The power supply is three AAA cells. There is a wire connecting the +3 volt power pin (pin 1) to the reset pin (RST, pin 16) to keep that pin high. That prevents the chip from constantly resetting itself. The LEDs are, in this case, simply soldered to each pair of output pins, so you have eight lights. You could also solder one leg of the LED to each output pin and the other leg to ground to get 16 lights flashing at random.

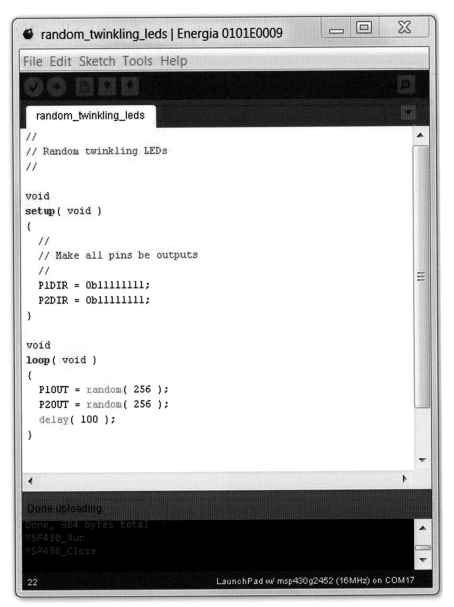

The program (http://artists.sci-toys.com/random_twinkling_leds.txt) is very simple.

```
//
// Random twinkling LEDs
//

void
setup( void )
{
  //
  // Make all pins be outputs
  //
  P1DIR = 0b11111111;
  P2DIR = 0b11111111;
}

void
loop( void )
{
  P1OUT = random( 256 );
  P2OUT = random( 256 );
  delay( 100 );
}
```

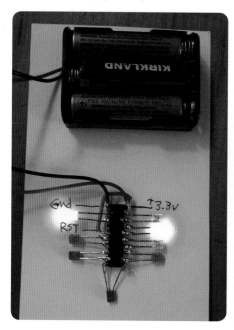

Set all of the pins to be outputs, and then use the random() function to get a number between 0 and 255. Then send that number to port 1. Do the same for port 2. You control how fast the LEDs flash using the delay() function. In this case, 100 milliseconds (1/10 of a second) gives some pretty frenetic flashing. Without the delay, the lights would simply appear to be on, since they would be flashing faster than your eye could detect.

When programming the extra chip, you must first remove the MSP430G2553 chip from the LaunchPad. Use a small slot screwdriver and gently work it under the pins until the chip is free. Try not to

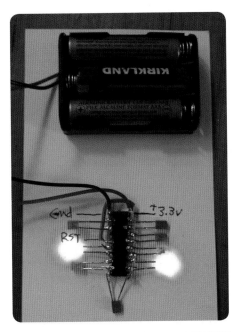

bend the pins, as repeated straightening weakens them. Then gently insert the new chip. The legs of the chip may be splayed out a little bit—this can be fixed by gently pressing the side of the chip against the desktop before trying to insert it.

Finally, you have to remember to change the setting of the Tools/Board menu from MSP430G2553 to MSP430G2452, as shown below:

# 6

# COMPUTER-CONTROLLED MOTORS

**Y**our little computer can put 3.3 volts on any of its output port pins. It can deliver as much as 40 milliamperes on a pin, although that is pushing things a little far, risking overheating the little chip. That's a total of 3.3 volts × 40 milliamperes, or 132 *milliwatts* of power.

While not a lot of power, it can drive small DC motors if they have light loads.

One little motor I tried spins nicely when attached to an output port pin, but since it is designed for a higher voltage (probably 5 to 12 volts), it is only drawing 13 milliamperes. That is only 43 milliwatts (3.3 volts × 13 milliamperes), which is not a lot of power, so the motor can only spin things like paper disks or small fans and would not be able to move something like a little robot car.

Motors designed to run on 3 volts or less draw more current. The little motors in pagers and cell phones that make them vibrate are designed for these low voltages, and the one I tested drew 40 milliamperes and vibrated like crazy, as it is designed to do. Small DC hobby motors designed for 3 volts, such as those you might salvage from a toy car that runs on a couple of AA cells, can drive little cars or move small sculpture parts. Bear in mind that two AA batteries in series provide 3 volts at 700 milliamperes, or 2100 milliwatts, so your little computer will not move the car very fast all by itself.

Nonetheless, sometimes you don't need a lot of power, and the simplicity of driving the motor directly from the computer's output pins makes life a lot easier (http://artists.sci-toys.com/motor_forward_and_reverse.txt):

```
motor_forward_and_reverse | Energia 0101E0009          ⎯  ⬜  ✕

File  Edit  Sketch  Tools  Help

 ✓  ➜  ⬜ ⬜ ⬜ ⬜                                            ⌕

 motor_forward_and_reverse                                  ▾
//
// Connect a small DC motor to pins P1.0 and P1.1
// Every second, this program will reverse the motor direction.
//
void
setup( void )
{
  P1DIR = 0b11;
  P1OUT = 1;        // P1.0 is at +3.3 volts, P1.1 is at 0 volts
}

void
loop( void )
{
  P1OUT ^= 0b11;   // Switch the state of the two lowest pins
  delay( 1000 );
}

◀                                                           ▶

Done Saving.

Binary sketch size: 313 bytes (of a 16,384 byte maximum)
Erasing...
Programming...
Done, 314 bytes total

 15                        LaunchPad w/ msp430g2553 (16MHz) on COM10
```

The little motor will run if one of its wires is connected to 3 volts or more and the other is connected to ground (0 volts). This means you can connect one wire to ground and the other wire to any output pin and run the motor by turning that pin on, just like lighting an LED.

But DC motors can run in either direction. If you connect the wires to two output pins and arrange for one of them to be on and the other off, the current will flow from the one that is on, through the motor, to the one that is off. This will make the motor spin. Reversing the states of the pins will make the motor spin the other way. Turning both pins on or both pins off will stop the motor.

That might be enough control for many projects, but you can do better. You can use pulse width modulation on the pins to control the motor speed. Just like making an LED dim or brighten, you can make the motor slow down or speed up by using PWM. You can do the PWM in software and use any output pins, or you can use the output pins that support hardware PWM.

## MORE POWER

For most motor projects, you will want more power than you can get directly from the pins of the microprocessor. The good news is that this is fairly easy. You can use a transistor to turn the power to the motor on and off, controlled by the pin from the microprocessor.

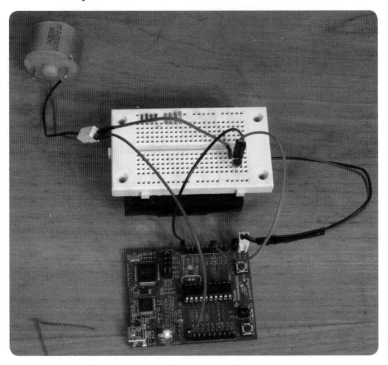

In the photo above, the motor is getting its power directly from the same place the computer is: a pair of C batteries in a battery holder under the solder-less breadboard.

The solderless breadboard has a transistor plugged into it. The transistor is acting as a switch. When the center pin of the transistor is brought up to 3 volts by the pin on the microprocessor, it turns the transistor on. The current then can flow through it, connecting the motor to the batteries. When the microproces-

sor pin is off (at 0 volts, the ground level), then the transistor turns off and the motor stops.

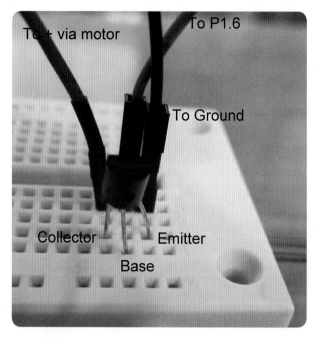

The transistor can be any NPN transistor, such as the 2N2222A transistor shown in the photo above.

You can use pulse width modulation to control the speed of the motor, but this circuit cannot change the direction of the motor.

Only a tiny amount of current is used from the computer pin, so the processor does not heat up. The transistor is controlling all of the current going through the motor, and it can handle a whopping 800 milliamperes. If you need more than that, there are power transistors that can handle many watts of power.

But you can get even more power from the little 2N2222A. You can raise the voltage up to as much as 60 volts. With 60 volts and 800 milliamperes, you can control 48 watts, which is more than most small DC motors can handle.

Here's how to do it. This example uses a 9-volt battery. The two power supplies (the C cells for the computer and the 9-volt for the motor) will have their grounds connected together. The black wire from the 9-volt battery is plugged into the hole in the solderless breadboard that the emitter of the transistor is

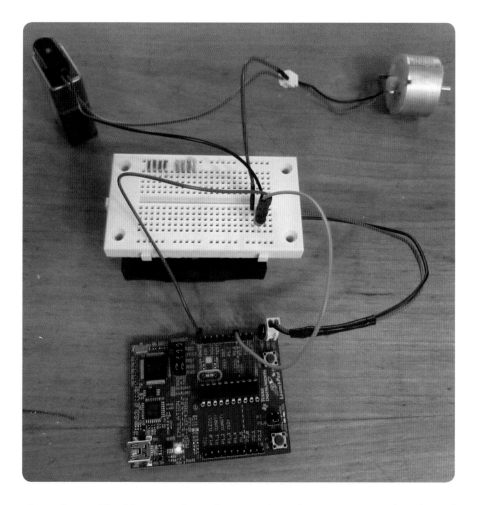

plugged into. The blue wire from the ground on the computer is also plugged into a hole that connects to the emitter.

The microprocessor pin is connected to the base, as it was before.

The positive (red) wire from the 9-volt battery is connected to the motor. The other wire from the motor is connected to the collector pin of the transistor.

When the microprocessor turns on the transistor, the current goes from the 9-volt battery into the motor. The battery for the computer is no longer powering the motor. The motor spins much faster, and can actually do some serious work now.

As before, you can control the speed using pulse width modulation.

Connecting the grounds of both power supplies (batteries in this case) gives the computer and the transistor a common reference point, so they both see the 3-volt signal from the computer pin as higher than ground. With the common reference point, they can agree on what an on or off signal is.

## An H-Bridge Chip to Control Power

So far you have driven motors forward by connecting them to two pins on the LaunchPad and setting one pin to HIGH and the other to LOW. You have driven them backward by setting the pins to LOW and HIGH.

To get more power, you added a transistor, but you lost the ability to reverse the motor, since the transistor can only connect the motor to one side of the power supply.

SN754410 chip

To get more power and still be able to reverse the motor, you need a chip called an *H-bridge*. It has several transistors in it, and they are all connected in a circuit inside the chip, so interfacing the LaunchPad and motor to it is very simple. The chip is called the SN754410.

In the photo on the previous page, you can see you are only using the left side of the SN754410 chip (pins 1 through 8). The only pin used on the right side is pin 16, which is what powers the input part of the chip. That part of the chip reads the LaunchPad pins, and it is powered by the LaunchPad's power supply.

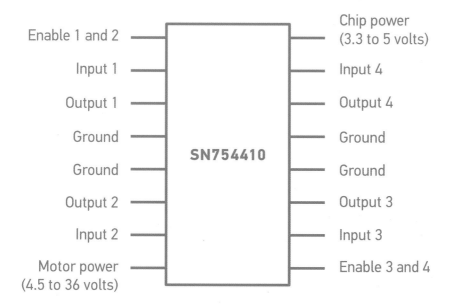

The output part of the chip is powered by a separate power supply (in this case a 9-volt battery). This is what drives the motor. The output side of the chip can handle a power supply with as much as 36 volts, allowing you to drive some pretty powerful motors.

The state of the SN754410's pin 2 (connected to the LaunchPad's port 1 pin 0) is "copied" to the SN754410's pin 3 but at the higher voltage.

Likewise, input pin 7 is copied to output pin 6 but at the higher voltage.

Here is the program (http://artists.sci-toys.com/h_bridge.txt):

```
void
setup( void )
{
  P1DIR = 0b10010001;  // port 1 pins 7, 4, and 0 are outputs
  P1OUT = 0b10010000;  // enable the H-bridge using pin 4
                       // and begin with pin 7 high and 1 low
  //P1OUT = 0;
}

void
loop( void )
{
  P1OUT ^= 0b10000001; // toggle pins 7 and 0 to reverse motor
  delay( 2000 );       // each direction for 2 seconds
}
```

In this project, you are running a single motor, so you only need to use the left side of the chip (pins 1 through 8) and pin 9. I chose to use the Launch-Pad's port 1 pins 0 and 6 to control the motor, since they are connected to the onboard red and green LEDs and you can see which direction the motor is supposed to spin by looking at the lights.

You could have connected pin 1 of the SN754410 to pin 9 so it would always be enabled. But enabling it in software allows you to power down the chip when you aren't using it and thus save battery power.

If you want to drive another motor, use the other side of the SN754410 chip.

## CONTROLLING SERVOMOTORS

A servomotor is a motor that has gears and a feedback system so that it can change its position, controlled by a pulse width modulation signal.

Unlike the motors you have played with earlier, servomotors typically don't spin around over and over again. Instead, they move an arm or lever through an arc, generally 180 degrees. You tell the servo how many degrees to move using pulse width modulation.

The servomotor has circuitry inside that contains a transistor to power the motor. This means you don't need any extra transistor to get more power. You can power the servomotor from a higher-voltage battery, just like you did in the previous section, by connecting the ground (0 volts) sides of the computer power supply and the servo power supply together.

The servomotor has three wires. They are the power, ground, and *control wires*. In the photo above, the power and ground of the computer are connected to the power and ground wires of the servomotor. The remaining wire—the control wire, also called the *signal wire*—is connected to pin P2.1 in this example. That pin will be driven by pulse width modulation to control how far the little arm on the servomotor will rotate.

```
ServoExample | Energia 0101E0009

File Edit Sketch Tools Help

ServoExample §

#include <Servo.h>

Servo servo;

void setup()
{
  servo.attach( P2_1 );
}

void loop()
{
  for( int x = 0; x < 180; x++ )
  {
    servo.write( x );
    delay( 15 );
  }

  for( int x = 180; x >= 1; x-- )
  {
    servo.write( x );
    delay( 15 );
  }
}
```

```
Done uploading.

Binary sketch size: 1,601 bytes (of a 16,384 byte maximum)

Erasing...
Programming...
Done, 1602 bytes total

1                              LaunchPad w/ msp430g2553 (16MHz) on COM10
```

This code for controlling servomotors (http://artists.sci-toys.com/servo _example.txt) uses a class called Servo. It calls the attach method of the servo object to tell it that you are controlling the servo using pin P2.1.

In the loop() function, you have two inner loops. The first one counts up to 180, and the second one counts back down to zero. Inside each loop, the loop counter is sent to the servomotor using the write() method on the servo object. Since the servo takes some time to move, you wait for 15 milliseconds after telling it where to go. If you were moving more than one degree, you would probably want to wait longer. Moving 180 degrees all at once might take 50 to 60 milliseconds.

Servomotors can be surprisingly powerful. Because they have gears, the motor can spin fast, and the gears translate that into slow but powerful motion.

Besides rotary servomotors, you can get linear servomotors, which move things back and forth in straight lines. You can also get much larger, more powerful servomotors and run them from more powerful power supplies, in case you need to move something with more muscle.

## CONTROLLING STEPPER MOTORS

A stepper motor is a motor that moves in steps instead of constantly rotating. Stepper motors are used a lot in things like printers, where a computer program needs to move something by an exact amount.

The simplest stepper motor you may have in your house is the little motor that drives a battery-powered quartz clock. It has only one coil (the stepper motors in printers have two), and since it is designed to run from a 1.5-volt AA cell, it is easy to drive it from the LaunchPad instead.

When you drive the clock with your computer, you can make time go as fast or as slowly as you wish. The project described here is one I call Ridgemont High. It drives the clock 50 times faster than normal, to give you "Fast Times." It runs so fast that sometimes when it starts up, the clock gets confused and runs backward. I can keep pushing the Reset button on the LaunchPad until I see the clock running backward. Sometimes it only takes two or three tries; at other times it takes 10 or more to get it to run backward: www.youtube.com /watch?v=oNTtGTGfa6A.

Building the project is fairly simple. Use a pair of wire cutters to carefully remove part of the plastic back from the clock movement. You don't want to completely open the back, since the clock gears are very hard to get back into place if you do that. But you can cut open the back until you find the coil of wire that is the heart of the motor, and keep cutting until you find the two wires where the fine motor wire is connected to the rest of the circuit.

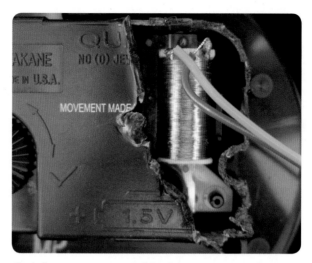

Once you find those two wires, solder longer wires to them so you can connect them to port 1 pin 4 and port 1 pin 5 of the LaunchPad.

I like to do all this cutting with the battery in the clock, and the clock running, so I know if I have damaged the clock or not.

Once the wires are soldered in place, remove the battery from the clock and connect the wires to the LaunchPad.

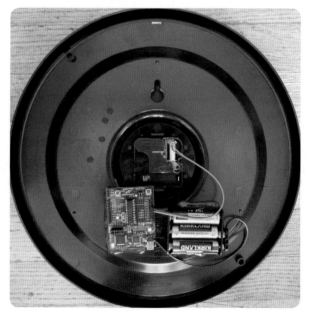

The program for running the clock at any speed (http://artists.sci-toys.com/ridgemont_high.txt) is very simple:

```
void
setup( void )
{
  P1DIR = 0b110000;
  P1OUT = 0b010000;
}

void
loop( void )
{
  P1OUT ^= 0b110000;
  delay( 20 );
}
```

To make the motor turn, first run the current one way through the coil, and then the other. You can do this by setting one pin high and the other low, and then reversing the pattern (so the high pin is now low and the low pin is now high). Each time you reverse the current, the second hand moves by one tick.

Use the *exclusive-or* operator to flip the bits:

```
P1OUT ^= 0b110000;
```

That line says to take any bit in pin 4 or 5 that has the value 1 and set that to 0. At the same time, any bit that was 0 is set to 0.

One of the great things about the little motor in the clock is that it uses very little power. It can run from the AA cell for a year or more. So if you have something you want to make move that does not need a powerful motor, such as a paper sculpture or a faceted crystal you want to place in a sunny window to make rainbows move around the room, you can modify the clock motor to run it and set the speed with the LaunchPad.

That said, when you are running the motor at 50 times its normal speed, it will use more power. To save power when running at normal speed, you could change the program so that the motor was only powered on for 20 milliseconds each second: http://artists.sci-toys.com/ridgemont_high_normal_time.txt. But 20 milliseconds seems to be close to the minimum time needed for this particular motor.

A more elaborate program could change the speed of the motor depending on some change in the environment or simply on the time of day. You could build a clock that ran normally until 9:00 AM, whereupon it would speed up, until lunchtime. Then it would slow down a lot, until the clock read 1:00 PM, when it would race forward again until 5:00 PM. The perfect clock for the clock-watching coworker who wants a long lunch hour.

## A More Versatile Stepper Motor

The stepper motors found in consumer appliances like printers and air conditioners generally have four coils instead of just one. One such motor is the

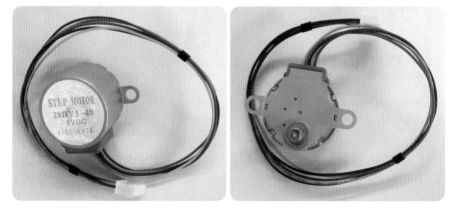

28BYJ-48. It has a motor that makes a full revolution in 64 steps and a set of gears that further reduces the speed (and increases the turning force) by 64.

In this motor, the coils are set up in pairs, and the center of each pair is connected to the red wire, which is connected to the positive side of the power supply. The power supply can be anything from 5 to 12 volts.

By connecting any of the other wires to ground, you can energize any of the coils. The coils are electromagnets that pull on little gear-like teeth in the motor. By controlling which coils are pulling at any time, you can make the motor step ¼₄ of a circle at a time, either clockwise or counterclockwise. Because of the gearing, you actually step 2,048 times to make the shaft turn one complete turn. This gives you a lot of control over the position of something you are moving.

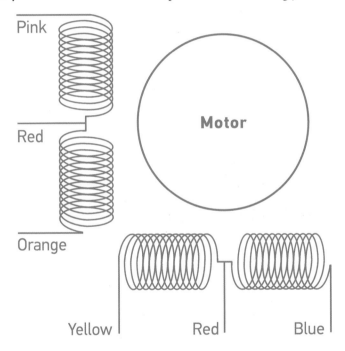

The diagram above shows how the colored wires connect to the coils.

Because the motor moves the same amount each time you step it, you can accurately move back and forth and always land on the same spot.

You do pay a price for the gear reduction in this motor, however. The gears have some play in them, so the shaft of the motor can move back and forth a little bit, causing positioning accuracy to suffer. More expensive stepper motors have more teeth in their rotors and have as many as 200 steps per revolution instead of just 64. These motors generally don't have gears and can accurately step without any play in the rotor.

Energia has a stepper motor library that takes all of the complexity out of driving stepper motors.

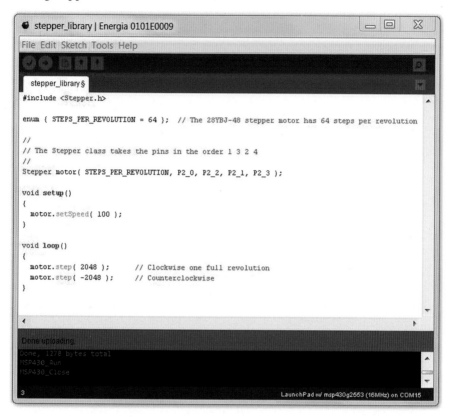

You simply include the header file for the library in your program (http://artists.sci-toys.com/stepper_using_library.txt), and make an instance of the Stepper class (you'll call your instance "motor"). Then you tell the motor to step some number of steps, using a positive number to step clockwise or a negative number to step counterclockwise.

That's all there is to it, as far as the software goes.

The problem comes when you realize that the LaunchPad can only put 3.3 volts on a pin and can't drive the 92 milliamperes needed to make the motor move. You need to add a transistor on each pin. That will both allow you to send a higher voltage to the motor and provide plenty of current to drive the motor.

Instead of using four separate transistors, you can use a convenient package of 16 transistors on a chip called the ULN2003A. The transistors are arranged in pairs (called a *Darlington pair*), which gives them more amplification and allows them to sink more current. You will only use half of the transistors in the chip, since you only have four coils to drive.

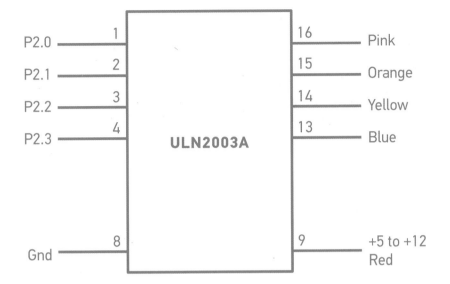

Connect the LaunchPad pins to pins 1 through 4 on the ULN2003A chip. Connect the colored wires on the motor to pins 16, 15, 14, 13, and 9 according to the illustration above. Pin 9 is also connected to the positive side of a power supply that can provide 5 to 12 volts. The negative side of that power supply is connected to pin 8. The LaunchPad's ground is also connected to pin 8, so the LaunchPad and the other power supply can agree on what 0 volts is.

Many suppliers sell the 28BYJ-48 stepper motor and a small circuit board containing the ULN2003A together as a package, making life even that much more convenient. One such circuit board, which also comes with LEDs to show which motor pins are being driven, is shown at left.

However, it is easy enough just to plug the ULN2003A (or, as in the case that follows, the very similar ULN2004A) chip into the solderless breadboard and connect it up. The photo on the next page shows a six-wire stepper motor (a Seiko Epson STP-35N148) being driven by the same demonstration program. It can handle 24 volts (it turns just fine on 4.5 volts, but 24 volts would move heavier loads). The two brown wires are connected to the two center taps of the coil pairs and to the positive power supply (pin 9 of the ULN2004A), just like the red wire in the five-wire motor.

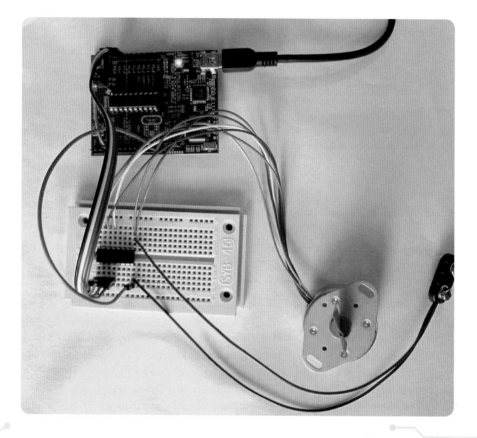

# PROJECT: MAKING MUSIC WITH YOUR COMPUTER

The little LaunchPad computer has three timers that can control three output pins. That means you can tell each of the timers to turn its pin high or low (on or off) at three different frequencies. If you select frequencies in the audible range (16 times per second up to 25,000 times per second) and attach a speaker to the pin, you can make tones humans can hear.

The timers will be simply turning the pin on and off, so the sounds will be the same as those used in early video games, sounding something like a harmonica or a bagpipe.

Because you have three timers, you can play three notes at once. That's not a lot, compared with what a piano player can do (using 10 fingers and a sustain pedal), but it is enough for many basic chords.

There is a lot of free music available on the Internet in the form of MIDI files. You can search for "free MIDI songs" and find almost anything.

I have written a program that can convert MIDI songs into source code for the three timers in the LaunchPad. If the song is playing more than three notes at once, the program does a fair job of selecting which notes are important to keep and which ones can be shortened or eliminated.

The program is here: http://artists.sci-toys.com/midi_to_launchpad.html.

The LaunchPad has enough memory for most of the songs you will find. If the song is particularly complex or long, the program will convert the entire song but it will comment out the past parts, so the program will still run, even though it cuts the song short.

The program you copy and paste into Energia to compile for the LaunchPad is actually fairly simple. It starts with a list of the frequencies for each note. Then there is a list of all the notes to be played. The code that does the playing of the notes is short enough to show here (http://artists.sci-toys.com/music):

```
const unsigned long int microseconds_per_tick = 4222UL;

enum { SILENCE=128 };

unsigned char last_timer1 = SILENCE;
unsigned char last_timer2 = SILENCE;
unsigned char last_timer3 = SILENCE;

void
setup( void )
{
  pinMode( PUSH2, INPUT_PULLUP );
  for( unsigned int which_event = 0; which_event < sizeof events / sizeof *events; which_event++ )
  {
    if( digitalRead( PUSH2 ) == LOW )
    {
      tone( P2_2, 0, 0 );
      tone( P2_3, 0, 0 );
      tone( P2_4, 0, 0 );
      break;
    }

    event e = events[ which_event ];

    if( e.timer1 != last_timer1 )
      tone( P2_2, notes[ e.timer1 ], -1 );
```

```
    if( e.timer1 != last_timer2 )
      tone( P2_3, notes[ e.timer2 ], -1 );

    if( e.timer3 != last_timer3 )
      tone( P2_4, notes[ e.timer3 ], -1 );

    last_timer1 = e.timer1;
    last_timer2 = e.timer2;
    last_timer3 = e.timer3;

    long int slp = microseconds_per_tick * e.sleep_for;
    delay( slp / 1000 );
    delayMicroseconds( slp % 1000 );
  }
}

void
loop( void )
{
    delay( 10000 );
}
```

Everything is done in the setup() function. This lets you start the song by pushing the Reset button on the LaunchPad. When the song ends, the Launch-Pad goes to sleep until the Reset button is pushed again.

The first thing you do in the setup() function is make the other button on the LaunchPad be an input so you can use it to stop the music. Then you loop through all of the events in the list. An event is a change to one, two, or all three of the notes you can play. If you need to change any note in the song, there is an event telling you what to change.

Inside the loop you check to see if the Stop button has been pushed. If it has, you stop all the timers and break out of the loop.

Otherwise, examine the next event, checking to see which note(s) may have changed. If a note has changed, the program calls the tone() function to tell the timer which pin to use and which note to play. Then you remember which notes are playing (so you can check for a change). Finally, it sleeps for as long as needed until the next event is to be processed.

To hear the music, you need to connect a speaker to the output pins (this program uses pins P2.2, P2.3, and P2.4). Speakers have two wires. One speaker

wire will be attached to the ground pin (GND), which is always at 0 volts. The other wire from the speaker goes to one of the three output pins.

If you only have one speaker, you can connect all three output pins together and attach the speaker wire to all three at once. But if you have three speakers, you can space them out so that the listener can hear the notes coming from different places, as if played by different instruments in an orchestra. Many MIDI songs sound like the melody is coming from pin P2.2, the bass from P2.3, and the percussion from P2.4.

# PROJECT: MAKING THE COMPUTER SPEAK

You can store a recording of your voice in the little computer to make it say things. The little computer doesn't have a lot of room for storing audio (it has 16,384 bytes, and the program has to live in that space too), but you can store a few seconds of digitized sound.

In the program on the next page, I have removed a huge section of code in the middle of the array called "data" to allow the whole program to be seen in a small image. The data is huge because it is almost a second of speech, recorded at 16,000 samples per second. So there are about 10,000 bytes in the array, and it goes on for several pages. The full program is available at http://artists.sci-toys .com/hello_there_16000hz.txt.

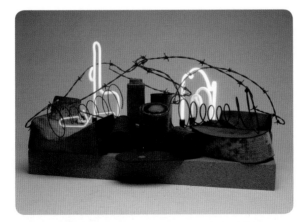

## STUDENT ART PROJECT

*Just Deserts* by Patrick Stafford, a desert scene done in handblown neon lights, uses a LaunchPad to play the sound of a pickup truck's tires rolling over a gravel road when the sonar sensor detects that a visitor has come to view the piece.

hello_there_16000hz | Energia 0101E0009

File Edit Sketch Tools Help

hello_there_16000hz §

```
//
// Converted from file hello_there_3.wav.
// Channels 1, Sample rate 16000
//

const unsigned char data[] = {
  0x89, 0x88, 0x81, 0x85, 0x8c, 0x8b, 0x86, 0x83, 0x81, 0x80, 0x84, 0x84,
  0x81, 0x7f, 0x7b, 0x7c, 0x7f, 0x80, 0x80, 0x7d, 0x79, 0x7b, 0x80, 0x80,
...
  0x77, 0x79, 0x7d, 0x81, 0x86, 0x8c, 0x91, 0x94, 0x96, 0x95, 0x92, 0x8e,
  0x89, 0x86, 0x83, 0x82, 0x80, 0x7e, 0x7c, 0x77
};

void
setup( void )
{
  P1DIR = 0b01000000;

  analogFrequency( 62500 );

  //
  // 8 bit data sent at 16,000 samples per second.
  //
  for( int x = 0; x < sizeof data / sizeof *data; x++ )
  {
    analogWrite( P1_6, data[x] );
    delayMicroseconds( 8 );
  }
}

void
loop( void )
{
  digitalWrite( P1_6, 0 );     // stop the PWM timer
  delay( 1000000 );
}
```

Done uploading

Binary sketch size: 10,937 bytes (of a 16,384 byte maximum)

Erasing...
Programming...
Done, 10938 bytes total

9                                    LaunchPad w/ msp430g2553 (16MHz) on COM10

I use the keyword "const" in front of the declaration to tell the compiler that this data is not going to change. This allows the compiler to put the data into the same place it puts the code (which, of course, also does not change during program execution). The little computer has 16,384 bytes of flash memory into which programs and data can be placed. It also has 512 bytes of RAM (random access memory) where variables that will change are stored, such as the variable X in the setup() function.

So this program takes up almost all of the space available on the little chip—almost 11,000 bytes out of the 16,384 available.

All of the work is done in the setup() function. Connect a speaker to pin P1.6 and ground. Set P1.6 to output and call the analogFrequency() function to set the PWM frequency to a very high value, in this case 62,500 times per second. The computer runs at 16 million times per second, and you want 256 levels (8 bits worth) for your PWM. Dividing 16 million by 256 gives 62,500.

As an example, suppose the value you want to send is halfway between silence and as loud as you can make the speaker go. Your PWM would then turn the P1.6 bit on for 128 cycles of the 16 megahertz computer clock and then off for another 128 clock ticks. You can do 62,500 of those every second.

You have recorded the sound at a rate of 16,000 samples per second. In the "for" loop in setup(), you go through the entire data array, calling analogWrite() to set up the PWM to the value in the array. To ensure that you send the samples at the 16,000 sample-per-second rate (so you don't sound like you are breathing helium), you delay for eight microseconds after each data byte is sent. In this way, almost four PWM cycles happen for each data byte (62,500 divided by 16,000 is about 3.9).

The loop() function just sleeps, to save battery power if you are running off batteries. But first you have to turn off the PWM timer, which would otherwise keep sending pulses to P1.6. You do that by using the digitalWrite() function, which has the side effect of turning off the analogWrite() timer. If you didn't do this, the speaker would waste battery power trying to stay in some position other than at rest.

To hear my voice, just press the Reset button on the LaunchPad. Every time the LaunchPad gets power or resets, the setup() function gets called and it sends out the data.

At this point you might be wondering where all that data came from. I recorded my voice saying "Hello there!" on my laptop computer. I told the recording software to save the recording as a .WAV file, using 8-bit samples at 16,000 samples per second. Then I uploaded the .WAV file into a program I wrote that converts the sound into C++ source code. I then used copy and paste to copy the code from the web browser to the Energia program to compile and run.

You can find the program to convert speech recordings into LaunchPad code here: http://artists.sci-toys.com/wave_to_launchpad.html.

The program is very simple to use. Click on the Choose File button to select the .WAV file you want to upload from your computer. Then click on the Submit button. A new window will pop up with the source code for you to copy.

The connections are simple and are shown in the image above.

The little LaunchPad computer can't drive the speaker as well as you might like. The sound coming from it might be hard to hear in a noisy room. But you can fairly easily amplify it using a single NPN transistor, such as the 2N2222A, or the 2N4401, or even the big TIP31 power transistor.

You connect the P1.6 pin to the base lead of the transistor (the middle lead in this example). Connect the ground to the emitter lead (the leftmost lead). Connect the speaker to the collector (the rightmost lead), and the other speaker lead connects to the +3.3-volt power supply of the LaunchPad (marked VCC on the board).

Below is a close-up of the transistor part of the circuit:

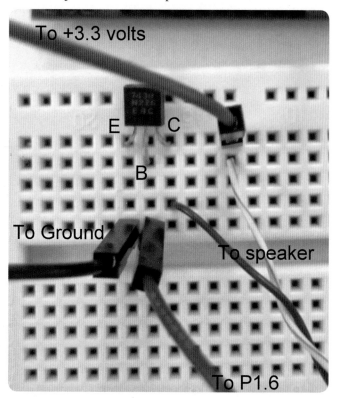

Now the sound comes out reasonably loud. But you can make it even louder by using a second power supply, just for the amplifier. Here is how to use a 9-volt battery:

Remove the connection to the +3.3 volts on the LaunchPad board. Keep the connection to ground, so the amplifier and the LaunchPad both agree on what 0 volts is.

Connect the negative side of the 9-volt battery to ground. The positive side goes to the speaker, in place of the wire that used to go to the +3.3 volts on the LaunchPad.

Now when pin P1.6 turns on the transistor switch, the 9-volt battery current goes through the speaker, instead of the previous 3.3 volts.

The result is substantially louder.

# 7

# SENSING THE WORLD

The LaunchPad computer has the ability to sense when things change in its environment. Simple changes, such as someone pressing on the onboard switch, have already been discussed to some extent. But the LaunchPad can also sense voltages on several of its pins, and it can use its timers to detect the width of HIGH or LOW pulses on an input pin. Using these capabilities, you can detect changes in light levels, temperature, distance to objects, pressure, sound, and many other things going on in the nearby environment.

Measuring temperature requires nothing but the LaunchPad itself. It has an internal temperature sensor. At the factory, technicians calibrated this sensor by recording its output at two different temperatures: 30 degrees Celsius and 85 degrees Celsius. They then wrote these two values into the memory on the chip. When the sensor is read, you can use the known values at those two temperatures to convert the reading into degrees.

The code is too long to show as a single image, but you can reference this link to see it: http://artists.sci-toys.com/temperature.txt.

The LaunchPad has an internal *analog-to-digital converter*. It can convert a voltage into a number the computer can use. The analog-to-digital converter—ADC for short—needs to compare the voltage to a known reference value. You can choose to use the voltage that runs the chip, but that might not be well regulated (you can run the chip from a battery, whose voltage drops as it weakens). But the LaunchPad chip also contains a 1.5-volt reference voltage that is quite stable and accurate. So you will use that. The setup and loop functions look like this:

```
● temperature | Energia 0101E0009                    ⊟  ▢  ✕

File  Edit  Sketch  Tools  Help

 ⊘⊙ ⬛🔲⬛

┌ temperature §

void
setup()
{
  analogReference( INTERNAL1V5 );
  analogRead( TEMPSENSOR );        // Throw away the first reading -- it is usually bogus

  Serial.begin( 9600 );
}

void
loop()
{
  double temp = temperature();
  Serial.print( "The temperature is " );
  Serial.print( temp );
  Serial.println( " degrees Fahrenheit" );

  delay( 10 );
}

Done uploading.
Done, 6776 bytes total
MSP430_Run
MSP430_Close

51                                 LaunchPad w/ msp430g2553 (16MHz) on COM12
```

In setup(), you use the function analogReference() to tell the chip to use the internal 1.5-volt reference. Then you use analogRead( TEMPSENSOR ) to read the temperature. You throw away the first reading, since it is generally unreliable.

In the loop() function, shown on the next page, you use your own function temperature() to read the temperature sensor many times and average the results, and then convert the average temperature into degrees, using the factory calibration values.

For those who would rather see the temperature in Celsius, I left that line in as a comment.

In this program I use the Serial class to send text back to the computer that is used to program the LaunchPad. In order for this to work, you need to change

temperature | Energia 0101E0009

File Edit Sketch Tools Help

temperature §

```
//
// A Program for reading the on-board temperature sensor.
// Prints a calibrated temperature in degrees Fahrenheit.
//

enum { SAMPLES_TO_AVERAGE = 500 };

double
temperature( void )
{
  //
  // Get the factory calibration values from the chip
  //
  volatile unsigned int *CAL_ADC_15T30_PTR = (unsigned int *) (0x10DA+0x08);
  volatile unsigned int *CAL_ADC_15T85_PTR = (unsigned int *) (0x10DA+0x0A);

  int cal30 = *CAL_ADC_15T30_PTR;
  int cal85 = *CAL_ADC_15T85_PTR;

  long int average = 0;
  for( int a = 0; a < SAMPLES_TO_AVERAGE; a++ )
  {
    average += analogRead( TEMPSENSOR ) * 100L;
    delay( 20 );
  }

  average /= SAMPLES_TO_AVERAGE;

  long int temp_minus_30_C = (average - cal30 * 100L) * 1000L;
  int x_distance = cal85 - cal30;
  long int counts_per_degree_C = (x_distance * 1000L) / (85L-30L);
  long int counts_per_degree_F = (x_distance * 1000L) / (185L-86L);

  // long int degrees_C = temp_minus_30_C / counts_per_degree_C + 30*100L;
  long int degrees_F = temp_minus_30_C / counts_per_degree_F + 86*100L;

  return degrees_F / 100.0;
}
```

Done uploading.
Done, 6776 bytes total
MSP430_Run
MSP430_Close

3                                    LaunchPad w/ msp430g2553 (16MHz) on COM12

the jumpers (labeled J3) on the LaunchPad board from their default "software UART" positions to the "hardware UART" positions. This is quite easy, as there is a picture printed on the board to remind you which way to set the jumpers. Pull out the two leftmost jumpers, turn them 90 degrees, and put them back, as shown in the photo below.

A *UART* is the universal asynchronous receiver/transmitter. That is geek speak for serial port—a way for computers to talk to one another.

Once you have set the jumpers and downloaded the program to the Launch-Pad, you can bring up the serial monitor window (using the Tools menu, Serial Monitor menu item, or just holding down the Control and Shift keys while you type M for "Monitor"). That window will show the text the LaunchPad is printing.

However, in a sculpture, you might use a servomotor to move an arm to indicate the temperature outside ("The temperature is this high . . ."). Or you might have the computer play a different tune depending on the temperature. Or maybe say something about the weather. Or just indicate the temperature using lights or an LCD display.

## USING LEDS AS LIGHT SENSORS

Light-emitting diodes work both ways—they emit light when you put power into the leads or they can generate power out of the leads when you put light into the lens. They are a type of solar cell, like what you might find in a calculator or on someone's roof.

The amount of power is tiny, since the little chip in the LED can't collect very much light energy, due to its small surface area. But the LaunchPad can detect and measure the power, using the analogRead() function.

You can attach an LED to one of the analog input pins, but you already have two LEDs mounted on the board—the red LED at P1.0, and the green LED at

P1.6—so you will use those for this demonstration (http://artists.sci-toys.com /two_led_light_sensor_with_graph.txt):

```
two_led_light_sensor_with_graph | Energia 0101E0009

File Edit Sketch Tools Help

two_led_light_sensor_with_graph §

enum { RED_LED_INPUT=A0, GREEN_LED_INPUT=A6 };

void
setup( void )
{
  analogReference( INTERNAL1V5 );
  Serial.begin( 9600 );
  pinMode( RED_LED_INPUT, INPUT );
  pinMode( GREEN_LED_INPUT, INPUT );
}

unsigned int
read_led( unsigned int which )
{
  unsigned long int level = 0;
  for( unsigned int x = 0; x < 500; x++ )
    level += analogRead( which );
  level /= 500;
  return level;
}

void
loop( void )
{
  unsigned int red_level = read_led( RED_LED_INPUT );
  unsigned int green_level = read_led( GREEN_LED_INPUT );
  for( unsigned int x = 0; x < red_level / 10; x++ )
    Serial.print( "*" );
  Serial.print( "    " );
  Serial.println( red_level );

  for( unsigned int x = 0; x < green_level / 10; x++ )
    Serial.print( "#" );
  Serial.print( "    " );
  Serial.println( green_level );
}

Done uploading.
Done, 2432 bytes total
MSP430_Run
MSP430_Close

20                           LaunchPad w/ msp430g2553 (16MHz) on COM12
```

In the setup() function, you set the internal voltage reference to 1.5 volts. This is what you will compare the voltage from the LED to. A red LED might produce 1.5 volts from a very bright light, and so the number you get back from

the analogRead() function would be 1,023, the highest value it can give. If you want to measure brighter light, you can set the internal voltage reference to 2.56 volts (using INTERNAL2V5) or use DEFAULT to let analogRead() compare to the 3.3-volt power supply.

Set the red and green LED pins to be inputs instead of outputs.

In the loop() function, read each of the LEDs and plot the reading on a poor man's graph, using asterisks for the red LED and number signs for the green LED.

The read_led() function reads the value of the LED 500 times, and averages. This gets rid of random variations in the readings, what engineers refer to as noise.

If you shine a light onto the LEDs, you can watch the graph change. As you move the light to shine more on one LED than the other, you can see one graph bar or the other (the asterisks or the number signs) get longer or shorter than the other.

With the ability to detect changes in light, your sculpture, robot, or other device can turn lights on when it gets dark, react to someone blocking a light, or react when a light is directed onto it. With two LEDs facing 90 degrees apart, you could have a flower that follows the sun or a robot that searches for a light to charge its batteries using solar panels. Some people build robots that follow a dark line on the ground, going around complicated courses by keeping the dark line always under the front-mounted sensors.

Using analogRead() to read the voltage produced by the LED is reasonably fast, but the LED is not very sensitive to low light levels when used in that fashion. There is another way to configure the LED as a light sensor, and it uses some tricks you learned very early in this book, when capacitors and their use as timers were discussed (page 33).

An LED is a block of semiconductor with two leads. Those two leads act as the plates of a capacitor. When you put a voltage on the LED in the wrong direction, so that it does not light up, the material between the two metal leads is not a conductor—it is an insulator. Two plates separated by an insulator is all a capacitor is, and the "reverse biased" LED is just that—a capacitor.

What makes the LED a particularly interesting capacitor is that it is light sensitive. When light strikes the semiconductor material between the two metal leads, it causes electrons to leave their atoms and become available to conduct electricity. So the LED material becomes slightly conductive when light hits it. When the capacitor is charged, one lead has a surplus of electrons, and the other has a deficit. If the material between them is not a good insulator, the electrons can move from the lead that has too many to the lead that is missing some. The charge stored in the capacitor seems to leak.

You can use this information to make a sensitive light detector. First, charge up the LED by putting a voltage across it in the "wrong" direction, the one that

does not cause it to glow. You do this by connecting the LED (backward) to a pin and setting that pin high. Then make that pin become an input. As an input, the pin sees the charge you put on the capacitor, and you read it as high. But if there is light hitting the LED, eventually the charge leaks away, and the voltage you are seeing on the input pin drops to low.

By timing how long this takes, you get a reading on how bright the light was (on average) that was hitting the LED (http://artists.sci-toys.com/sensitive _proximity_detector.txt):

```
//
// A more sensitive LED light detector.
// The LED connected to P2.0 and P2.1 is the sensor.
// It should not light up (if it does, you have it in backwards).
// The LED connected to P2.2 and P2.3 should light up -- it is
// the LED that illuminates anything in front of us.
//
enum
{
    CHARGE_THE_LED=0b01, READ_THE_LED=~0b01, NO_PULLUP=~0b01, LED_HAS_CHARGE=0b01, LED_PINS=0b11
};

void
setup( void )
{
    delay( 5000 );
    Serial.begin( 9600 );
    Serial.println( "Light sensor demo" );
    P2DIR = 0b1100;
    P2OUT = 0b1000;
}

void
loop( void )
{
    P2DIR |= LED_PINS;
    P2OUT |= CHARGE_THE_LED;
    P2DIR &= READ_THE_LED;
    P2OUT &= NO_PULLUP;

    unsigned long count = 0;
    while( P2IN & LED_HAS_CHARGE )
        count++;
    for( unsigned x = 0; x < count/10000; x++ )
        Serial.print( "#" );
    Serial.println( "" );
}
```

This trick gives you a very sensitive light detector (the LED I tested gave me readings of about 20 counts when in bright light to more than 2 million when I cupped my hand over the LED). That is equal to 16 bits of resolution, compared with the 10 bits available to analogRead().

The drawback is that it takes more time to get a reading in low light than the analogRead() function did. But since analogRead() gave you no ability to read such low levels, and no ability to read very bright light levels, this more sensitive detector has a place in your tool kit.

As a proximity detector (when combined with another LED to light up whatever is in front of it), the sensor was reliably detecting my hand from over a foot away when the room was dark. Using infrared or color filters might give good results even in a bright setting.

## PROXIMITY SWITCH

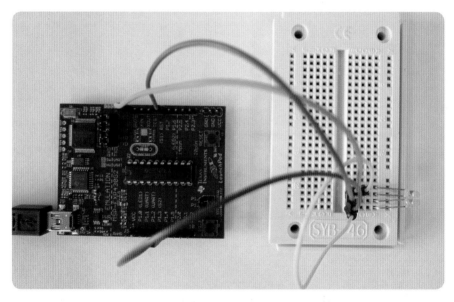

The circuit above shows the LaunchPad connected to an external white LED and an external red LED.

The white LED is connected to port 1 pin 7 and ground. The red LED is connected to port 1 pin 4 and ground.

The program at http://artists.sci-toys.com/simple_proximity_switch.txt keeps the white LED on and uses the red LED as a light detector. When you put something in front of the white LED, the red LED detects the reflected light, and that is read as a value returned from analogRead( A4 ).

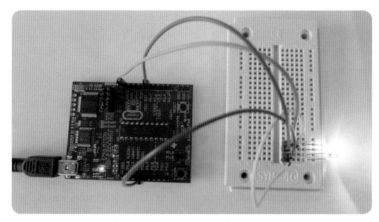

The value is usually about 600 when nothing is reflecting the light back. When the light is detected, the value drops, reaching 0 if a white card is within about a quarter of an inch.

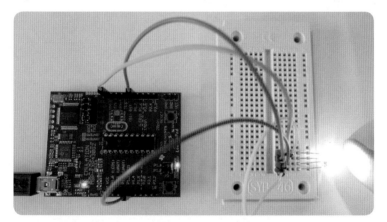

The program collects 100 readings in setup() to establish a baseline value for the condition when nothing is detected in front of the LEDs. It saves the largest value seen.

In the loop() function, you again read a value and convert it to a percentage of the maximum by first multiplying by 100 and then dividing by the saved maximum value.

If the percentage is less than 50 percent, you have detected something in front of the LEDs, and you turn on the onboard green LED to indicate that.

You selected the 50 percent value because there is a lot of variation in the readings, even when it looks like nothing has changed. Engineers call this kind of variation "noise in the signal," and there are ways of dealing with it, to reduce its effects.

A second program, at http://artists.sci-toys.com/smoothed_proximity_switch
.txt, smooths out the variations and allows you to use a 90 percent level as the
criterion. You first collect 64 values and sort them, so the low values are at the
top of the list and the high values are at the bottom. Then throw away the high-
est eight values and the lowest eight values, and average the values in between.
The result is a much more consistent reading, with less variation caused by ran-
dom effects. The variation you see correlates much better with actual changes in
the distance between the LEDs and any object in front of them.

## SONAR

The photo on the previous page shows a sonar sensor called the HC-SR04 plugged into a solderless breadboard.

The sonar sensor sends out a pulse of ultrasound, well above the hearing range of people and animals. When it hears the echo, it brings one of its pins from ground to +5 volts, for a period that corresponds to how long it took the echo to come back.

Since the HC-SR04 is designed to run at 5 volts, you can't simply power it from the LaunchPad's 3.3-volt power supply. You have to find 5 volts somewhere.

You could simply use a second power supply and connect the grounds together so the computer and the HC-SR04 both agree on what the 0-volt level is. But it just so happens that the LaunchPad gets 5 volts from the USB port of the computer it is attached to, and there is a hole in the circuit board you can solder a wire to that is connected to that 5 volts.

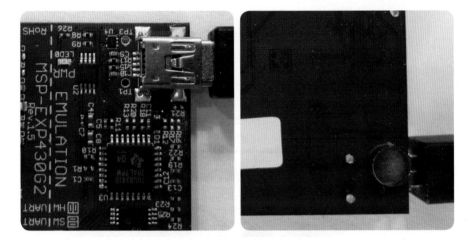

The hole in the circuit board is labeled TP1, which stands for test point 1. It is easy to insert a wire into the hole and solder it in place on the backside of the board, because there is almost nothing you can damage or mess up on that side. Even a novice at soldering can safely solder a wire there.

In the photo above you can see the two holes next to the USB connector at the bottom right. The upper of the two holes is TP1.

The HC-SR04 puts out 5-volt signals, which the LaunchPad can't read. You need to drop the voltage down to between 1 and 3.3 volts. The simplest way to do this is to limit the current with a 1,000-ohm resistor. Because there is less current, the voltage will drop to something the LaunchPad can handle.

The HC-SR04 has four pins. Connect +5 volts to the pin labeled Vcc. Connect the pin labeled Gnd to ground. The Echo pin is the output that needs to have the 1,000-ohm resistor. The other side of that resistor goes to an input pin. In the example program, that will be port 2 pin 1.

The remaining pin is the Trig pin. Setting that pin high tells the device to send out a pulse of ultrasound. The LaunchPad can raise this pin to 3.3 volts, which is short of the 5 volts that the HC-SR04 expects but high enough to be accepted as a HIGH signal.

In the example program at http://artists.sci-toys.com/sonar.txt, the setup() function starts the serial port after a five-second delay to allow you to bring up the serial monitor window. It then prints a startup message and sets up the port pins.

In the loop() function, you get the average distance the sonar sensor sees in front of it, and print that out. Then you send out a beep to a speaker connected to port 2 pin 3. The frequency of the tone corresponds to the distance between the sensor and what it is sensing.

The program has its own beep() function, because the tone() function supplied in the standard library uses a timer that is also used by pulseIn(), and it will need to use the pulseIn() function to read the sonar sensor.

The get_distance() function is what does the sonar sensor reading. It sends out a five-microsecond pulse to the sensor's Trig pin to tell the sensor to send out a sonar pulse. Then you time the resulting signal from the Echo pin using pulseIn(), which returns the length of the pulse in microseconds. Convert that time to centimeters by dividing by twice the speed of sound in microseconds per centimeter (which works out to be 58.77).

As you did with the LED proximity sensor, you filter the results by sorting samples and averaging those near the median.

As you move your hand toward the sensor, the pitch of the beeps rises. As you move away, the pitch falls.

## PIEZOELECTRIC TAP SENSOR

Inexpensive *piezoelectric elements* are usually used to make sound. But in this project you will use one to generate a voltage when it is tapped lightly with a finger.

Connect the piezoelectric element to port 1 pin 4 and ground, as shown in the above photo. Now you can simply loop, sampling port 1 pin 4 with digitalRead() or analogRead(), but that approach has two problems. First, by doing things that way, you might miss an event that has a very short duration, especially if you are doing anything else in the loop. Second, and related to the first, it means that you can't do much else in the loop for fear of missing a short event like a finger tap on the sensor.

However, the LaunchPad has a feature you haven't yet used that makes those problems go away. You can tell the LaunchPad that if port 1 pin 4 goes from low to high, you want the processor to interrupt whatever you are doing and call one of your functions.

The function you want to have execute when the pin goes high is called felt_tap(). All it does is change a variable from false to true. You generally want to keep interrupt routines very short so they execute quickly and don't interrupt other processes much. It is somewhat like getting a phone call while you are driving—if your attention is drawn away from the road for too long, bad things can happen.

The variable you are changing must be declared volatile so the compiler knows that it can change out from under you at any moment. Otherwise the compiler might notice that it does not seem to ever change and might optimize the code to eliminate any uses of it.

In setup(), you tell the LaunchPad that felt_tap() is supposed to be called on during rising transitions of the pin by using this line:

```
attachInterrupt( P1_4, felt_tap, RISING );
```

Just for fun, you also want to use the piezo element for its more common purpose: to make noise. To do that, you need to convert the pin from an input to an output. But you also want to tell the LaunchPad not to interrupt while you are using the pin as an output, because otherwise the moment you make the pin an input again, you would get an interrupt and mistake it for a finger tap.

So the beep() function detaches the interrupt routine from the pin using the line

```
detachInterrupt( P1_4 );
```

Then beep() sets the pin to be an output, toggles it at the right frequency for the right amount of time so you hear a beep, and then sets it back to being an input and attaches the interrupt function again before it returns.

In the loop() function, you want to ignore any bouncing you get when the sensor is tapped. When you touch the sensor, it might give you many interrupts in a row as the sensor creates several spikes of voltage due to continued flexing of the piezoelectric ceramic. So you use the function millis() to ask how many milliseconds have elapsed since the LaunchPad was turned on. Then you ignore any incoming events for the next 100 milliseconds. That gives the sensor time to settle down.

Turn on the green onboard LED when it first detects a tap. The next tap turns it off. If you are turning the green light on, you also call beep(), to give extra feedback to the user. You get an input device and an output device in the same little package (http://artists.sci-toys.com/tap_sensor.txt).

```
//
// Using a piezoelectric element as a touch sensor.
//
// Connect a piezo element to port 1 pin 4 and ground.
// When you tap on it, a message is printed, and the green LED is toggled.
// We then use the piezo element for output, and beep.
//
// To make the beeps louder, place (or glue) the piezo element to the bottom
// of a paper cup to act as a diaphragm and megaphone.
//

volatile int was_tapped = false;

//
// The function felt_tap() is called whenever someone taps on the piezo element
//
void
felt_tap( void )
{
  was_tapped = true;
}

void
beep( void )
{
  detachInterrupt( P1_4 );
  pinMode( P1_4, OUTPUT );

  for( int x = 0; x < 1000; x++ )
  {
    P1OUT ^= BIT4;
    delay( 1 );
  }

  pinMode( P1_4, INPUT );
  attachInterrupt( P1_4, felt_tap, RISING );
}

void
setup( void )
```

```
{
  Serial.begin( 9600 );
  pinMode( GREEN_LED, OUTPUT );
  attachInterrupt( P1_4, felt_tap, RISING );

  //
  // Just for fun, use the piezoelectric element to make a short beep at first...
  //
  beep();
}

long unsigned int old_millis = 0;
int count = 0;

void
loop( void )
{
  if( was_tapped && millis() < old_millis+100 )
  {
    Serial.print( count++ );
    Serial.println( "  Someone tapped!" );
    was_tapped = false;
    P1OUT ^= BIT6;
    if( P1OUT & BIT6 )        // Just for fun, beep when LED lights
      beep();
  }
  old_millis = millis();
}
```

# PROJECT: CECIL, A SESSILE ROBOT

When building an electronic sculpture, you are usually interested in giving it behavior. You don't simply want to have it flash lights and move motors, you want it to interact with its environment as if it were alive. This kind of behavior is called *agency*.

Cecil is a sock puppet made to look like a sea serpent. The photo on the next page shows him without his sock puppet skin, so you can see his inner workings. His eyes are the two *ultrasonic transducers* that view the area immediately in front of him and notice changes in the distance between the robot and people passing by.

When at rest, Cecil stands up straight. If he notices that something is within about a meter in front of him, he leans forward, as if curious. This is accompanied by the sound of the gears in his servomotor, which attracts the attention of a person passing by. If that person comes within about a foot of Cecil, he starts backing away, as if apprehensive about someone invading his personal space.

This simple behavior is enough to delight anyone coming in contact with him for the first time. He seems to have agency, giving a sense that he has a mind and that he has feelings such as curiosity and shyness.

Hidden in Cecil's wooden box base is a LaunchPad and a solderless breadboard. The breadboard is not really even needed, as it is only used to hold a single resistor that could easily have been soldered to the wire leading to the sonar sensor. As you saw in the first sonar sensor program (page 134), that resistor allows the 5-volt sonar sensor to communicate with the 3.3-volt LaunchPad.

The other piece to Cecil is his servomotor. No other electronic parts are needed.

A simple trick of geometry is used to keep Cecil's head level as he leans forward and back. You form a parallelogram of wood slats, or in this case foam-core board, which makes prototyping fast and easy. The hinges are simply clear packing tape. As you push on a parallelogram, it can become a rectangle when the sides are upright, or it can slant forward or back, but at all times the top side is level with the bottom side. This keeps Cecil's sonar sensor always looking forward, never upward or downward.

The servo is connected to the back slat by a stiff steel wire, as seen in the photo to the left. As the servo turns, it either pushes or pulls on the back slat, by means of the stiff wire.

See the sections on servomotors (pages 54 and 104) and the sonar sensor (page 134) for details on how to connect and use these parts. They are simple, and your little robot goes together quickly.

The code for detecting distance using the sonar sensor is taken from that project and is explained there. The rest of the code should be simple to follow; see http://artists.sci-toys.com/cecil.txt. The loop() function gets the distance, and if nothing is detected, it directs Cecil to straighten up. If something is within about 3 feet or so, the code calls lean_in(). If the distance is a foot or less, the code calls back_up().

The lean_in() function decrements the angle of the servo a little bit each time it is called, until it reaches a limit (MIN_ANGLE). The back_up() function does the same thing in reverse. The straighten_up() function changes the angle by one degreee in the direction of 90 degrees each time it is called.

In setup(), you use P2.0 for the servomotor output, P2.1 for the sonar sensor input, and P2.2 for the sonar trigger. Wait six seconds before printing anything to give you time to open the serial monitor window.

# PROJECT: ROVER, A SIMPLE WHEELED ROBOT

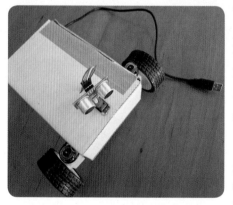

There is nothing new to learn in this project. It is just a collection of things you have already done. You built a motor controller using the SN754410 H-bridge chip (page 102). You controlled servomotors (page 104). You detected distance using sonar (page 134).

All of those projects come together in Rover, a little robot that scans his surroundings and rolls along while avoiding obstacles. This project is based on some very clever designs by Alexander Reben, to which I have added extra goodies (like the sonar scanner) and all the software, which you'll find at http://artists.sci-toys.com/rover.txt.

The photo above shows Rover as seen from above. You can see the HC-SR04 sonar sensor is glued to the arm of a small servomotor. The servo can thus rotate the sonar sensor to get an idea of the distances in front of the robot, allowing him to know where obstacles are in front and to the side and where the wide-open spaces are.

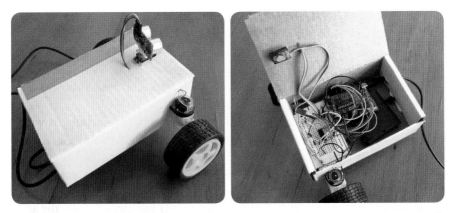

From behind you can see that there are two yellow DC gear motors with wheels, attached to a cardboard box with cable ties. A third cable tie is seen in the back, acting as a rear ski for low-friction support. Each of the two motors can move in forward or reverse, allowing the robot to spin left or right in place, or move forward and back.

Opening up the lid shows Rover's insides, a crazy rat's nest of wires but simple to understand when you look at each function separately.

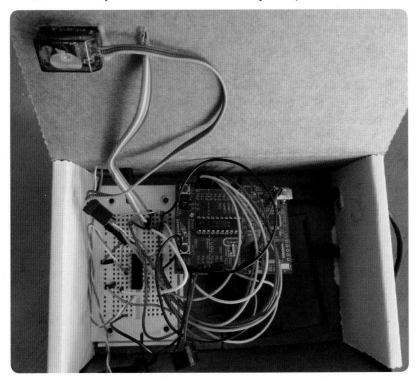

The black box under the LaunchPad holds 4 AA cells, used for power when the robot is not connected to the USB port. That provides 4.5 volts, which is enough to power the sonar sensor and the DC motors. The black ground lead from the batteries is stuck in an empty hole in the solderless breadboard when the robot is not powered up. To turn the robot on, that lead is placed in a hole connected to one of the four ground pins on the SN754410 H-bridge chip. That saves having to buy a switch.

Both sides of the H-bridge chip are used, since Rover has two motors.

The wheel on the right is connected to the H-bridge so that the LaunchPad's P1.2 and P1.4 control whether the wheel is off, moves forward, or moves back. The left wheel is controlled by the LaunchPad's P1.6 and P1.7.

The sonar sensor is connected to P2.2 for the trigger and P2.1 for the echo. The echo has a 1,000-ohm resistor between the sensor and the LaunchPad. The sensor is powered from the battery, since it needs 4.5 to 5 volts.

The servomotor is controlled by P2.0. It gets its power from the battery.

A tiny speaker is attached between P2.3 and ground so that the robot can beep.

A clever trick Alexander Reben used is to take the box the LaunchPad came in and carefully turn it inside out so the outside is white. This is used for the body of the robot. (In the photos for this secton, I actually used a different but similar box I had lying around.)

Some ideas for improvements:

Mount the batteries on top of the robot and give them a female USB connector. Then the "tail" of the robot would plug into the batteries to act as the power switch. Inside the robot, the 5-volt power could come from a wire soldered to the LaunchPad's TP1 test point near the USB connector.

Use the LED proximity switch (page 132, mounted so it looks down in front of the robot) so the robot can tell if it is about to fall off the table.

Write more code to control the robot's behavior. You can use the proximity switch to let it follow a black line on a white surface, for example, by putting two detector LEDs on either side of the white LED. Now the robot can follow a complicated course that you draw on paper with a black felt pen.

Replace the motors and servo with quiet stepper motors so the robot can sneak up on people.

# 8

# COMMUNICATION

The LaunchPad can communicate with people, other computers (such as a laptop), other LaunchPads, or devices such as televisions and table lamps.

You have used LEDs and speakers to communicate with people. Sometimes DC motors, servomotors, or stepper motors are used to communicate with people by moving signs or waving robot arms. An art piece such as a sculpture or jewelry could communicate with the viewer or wearer, and interact with him or her.

Communicating with a larger host computer allows the LaunchPad to interact with the Internet or with a person typing on a keyboard. Artists could thus control an art piece using the mouse and keyboard on their laptop computer and send the LaunchPad signals to control the piece. Or the laptop could send the host computer data such as the number of visitors it has interacted with, or the state of its batteries, or some error condition if the piece is damaged.

You have already played with using the Serial class to send information such as temperature or debugging messages to the host computer. You have also seen how to use the Serial class to control the brightness of 14 LEDs at once (http://artists.sci-toys.com/serial_pwm.txt) by sending short commands from the host computer.

Some projects might require more resources (pins, timers, or computational power) than a single LaunchPad can deliver. Connecting two or more Launch-Pads together in a network allows you to have more resources to devote to the project.

The LaunchPad is also able to control other devices and appliances. You have seen how you can control 120-volt power to lamps and motors, but you can also send infrared signals to anything that uses an infrared remote control, such as a television, audio device, camera, or even parts scavenged from a toy helicopter. Infrared remote controls use infrared LEDs to send the signal, and you are already adept at controlling LEDs.

## BUTTONS

For the most part, using the button on the LaunchPad is pretty easy:

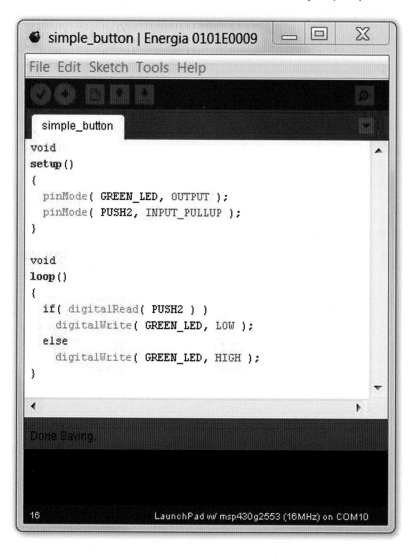

You run the code (http://artists.sci-toys.com/simple_button.txt), press the button, and the light comes on. You run into problems immediately, however, if you try to count the button pushes:

```
bouncy_button | Energia 0101E0009

File Edit Sketch Tools Help

bouncy_button §
{
  pinMode( GREEN_LED, OUTPUT );
  pinMode( PUSH2, INPUT_PULLUP );
  Serial.begin( 9600 );
  Serial.println( "Push button three times" );
}

unsigned count = 0;
unsigned old_state = 0;

void
loop()
{
  int state = digitalRead( PUSH2 );
  if( state != old_state && state == LOW )
    count++;
  old_state = state;
  if( count > 2 )
  {
    Serial.println( "Three!" );
    count = 0;
  }
}
```

```
Done uploading.
Done, 1972 bytes total
MSP430_Run
MSP430_Close
22              LaunchPad w/ msp430g2553 (16MHz) on COM18
```

The program on the previous page does not work properly. You will find that the program sometimes prints "Three!" after only one or two button presses.

This is because mechanical buttons bounce when you push them. Each push connects the contacts in the button, but then the contacts bounce away and disconnect before connecting again, often several times. The LaunchPad is so fast that it can ask the state of the switch many times during this bouncing period and get different answers as to whether the contacts are closed or not.

You need to add code to "debounce" the switch. This is not quite as simple as waiting until the bouncing has stopped. You must make sure that you wait less than 50 milliseconds so that the response to the switch still seems instantaneous to a human, and you want to avoid triggering on electrical noise generated by static electricity or nearby motors causing spikes in voltage.

One way to do this is to examine the switch multiple times and look for a pattern that has any number of "true" states (the switch was closed when you looked) followed by 12 states in a row where the switch was definitely closed. You can do that by using some tricky bit-twiddling code in the function closed() in the program (http://artists.sci-toys.com/debounced_button.txt) shown on the next page.

You have a variable called *s* that is static—that is, it retains the information in it across function calls. It can hold 16 states, one per bit.

Shift the variable left so each new state is added as the lowest bit.

Then you "or" in the value 0xE000. This makes the top three bits always be 1 bits. That will mean that you don't care whether they were on or off in the comparison on the next line.

The next line asks if the value in *s* is exactly 0xF000—or, in other words, any number of 1 bits followed by exactly 12 0 bits. If this is true, then you have detected when the switch has stopped bouncing and has been fully closed for 12 samples.

The next time you call closed() it will return false, because you are no longer at the precise point when the switch was closed. It may be closed or still open; you don't care.

Note that you have to check closed() multiple times before you get a true. This is usually done in a loop (as you did here) or in a timer routine. You can call closed() every four milliseconds and still be inside the 50-millisecond response window.

Walk through the code in your head until you are sure you understand it. It is a bit tricky but very useful.

```
debounced_button | Energia 0101E0009

File Edit Sketch Tools Help

debounced_button
void
setup()
{
  pinMode( PUSH2, INPUT_PULLUP );
  Serial.begin( 9600 );
  Serial.println( "Push button three times" );
}

//
// Detect the instant we are sure the switch has just closed
//
bool
closed( void )
{
  static unsigned short s = 0;
  s <<= 1;
  s |= digitalRead( PUSH2 );
  s |= 0xE000;             // If we see any of four states open
  if( s == 0xF000 )        // followed by 12 closed states in a row
    return true;           // then we have detected the edge
  return false;            // Otherwise the switch is still open
}

unsigned count = 0;

void
loop()
{
  if( closed() )
    count++;
  if( count > 2 )
  {
    Serial.println( "Three!" );
    count = 0;
  }
}
```

Done Saving
Done, 2086 bytes total
MSP430_Run
MSP430_Close

13                                    LaunchPad w/ msp430g2553 (16MHz) on COM18

## AN LCD TEXT DISPLAY

Up to this point, you have done communication between the LaunchPad and the human user using blinking LEDs, sounds, and the serial monitor. In this project, the inexpensive 2-line-by-16-character LCD display is introduced.

These displays allow you to communicate text messages to the user without requiring another computer to display them.

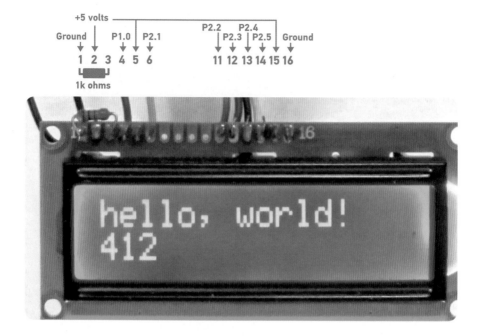

The photo above shows such a display. This one has white letters on a blue background, lit by an internal white LED backlight.

The display is powered by 5 volts, so you need to get the power from the TP1 test point on the LaunchPad, as you did when you used the sonar sensor. Pin 1 on the LCD display is ground, and pin 2 is 5 volts. The third pin controls the contrast of the display. I find that a simple 1k-ohm resistor between this pin and ground gives nice contrast on the display. To make the contrast adjustable, you can connect a potentiometer between ground and 5 volts and connect the wiper terminal of the potentiometer to pin 3. I find it usually is not necessary.

Pins 15 and 16 are connected to 5 volts and ground to light the LED backlight. You can add a resistor between pin 15 and 5 volts to dim the LED and save some battery power if you like.

Pin 4 on the LCD display is the Register Select. When low, data coming in is interpreted as a command. When high, data coming in is interpreted as text to display. Connect this pin to the LaunchPad's P1.0 pin.

Pin 6 is the Clock Enable pin. Connect that to the LaunchPad's P2.1 pin.

The data pins are 11 through 14. Connect these to the LaunchPad's P2.2, P2.3, P2.4, and P2.5 pins.

The bottom view of the board shows that pins 16 and 1 have been connected with a jumper, and pins 15, 5, and 2 with two more jumpers.

The LaunchPad and display can be seen connected together in the following photo:

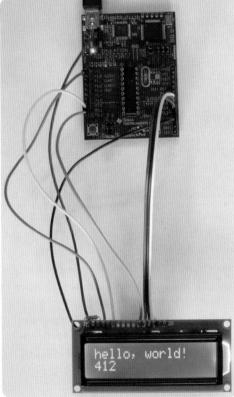

The Energia software comes with a library that makes sending text to the LCD display very simple (http://artists.sci-toys.com/minimal_lcd.txt). Printing the words "Hi there!" is as easy as this:

The library contains code that lets you select the row and column where you wish to print, code for clearing the screen, and other simple functions. It also has an "autoscroll" function that turns on a feature in the module that is supposed to make it easy to send characters that scroll off the screen when new characters come in. However, it seems to behave in strange ways, jumping from one row to the other at strange times. But since writing code to scroll properly is not difficult and takes up little space in the LaunchPad, I just wrote my own code when I wanted a program to receive serial data from other devices and display it on the LCD panel (http://artists.sci-toys.com/lcd_serial.txt).

When you load that program onto the LaunchPad, whatever you type in the top line of the serial monitor gets displayed on the LCD screen. To actually see it handling special characters like carriage return, line feed, and backspace, you will want something a little better than the serial monitor, such as HyperTerminal, PuTTY, or some other terminal-emulation program running on your computer.

## COMMUNICATING BETWEEN A LAUNCHPAD AND ANOTHER MSP430 CHIP

The LaunchPad comes with an extra MSP430 chip, the MSP430G2452. In this project you will get to play with it again, since you want to extend the capabilities of your LaunchPad to control more LEDs.

First you will build the 14-pin PWM circuit from the Serial PWM section (page 88). You do it on a solderless breadboard as shown in the photo below:

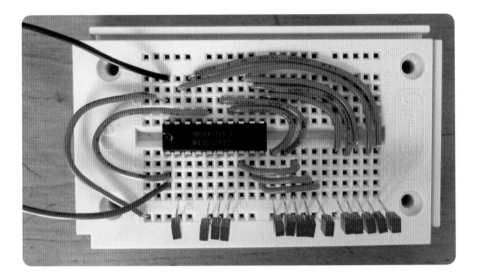

In this photo, the extra chip is mounted on the breadboard. Connect the Reset pin to the +3 volts of the power supply so the chip does not constantly reset itself.

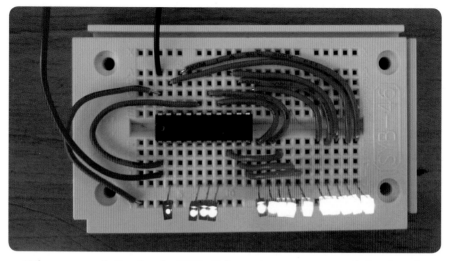

When you apply 3 volts, the LEDs light up, getting successively brighter from left to right.

Notice that you have not connected anything to pins P1.1 and P1.2 yet. Those are the serial port pins. Since this chip is not mounted in the LaunchPad board, you can't send serial data to it from the host computer, as you have done in the past. But you can connect the serial port pins of the chip in the Launch-Pad to the serial port pins of the chip on the breadboard, and they can talk to one another.

In the photo at the bottom of the previous page, you can see the LaunchPad connected to the breadboard circuit. P1.1 of each chip is connected to the other, as is P1.2.

```
serial_send_to_pwm_chip | Energia 0101E0009

File  Edit  Sketch  Tools  Help

serial_send_to_pwm_chip §

unsigned limits[16] = { 1, 2, 4, 16, 64, 128, 64, 16, 4, 2, 1, 0, 0, 0 };

void
setup( void )
{
  Serial.begin( 9600 );
}

char h[] = "0123456789ABCDEF";

char
hex( unsigned val )
{
  return h[ val & 0b1111 ];
}

void
move( unsigned where )
{
  for( unsigned x = 0; x < 16; x++ )
  {
    Serial.print( hex( where + x ) );
    Serial.print( hex( limits[x] >> 4 ) );
    Serial.println( hex( limits[x] ) );
  }
  delay( 50 );
}

void
loop( void )
{
  for( unsigned a = 0; a < 5; a++ )
    move( a );

  for( unsigned a = 5; a > 0; a-- )
    move( a );
}
```

Done uploading
Done, 1972 bytes total
MSP430_Run
MSP430_Close

26                                        LaunchPad w/ msp430g2553 (16MHz) on COM18

The program (http://artists.sci-toys.com/send_to_serial_pwm.txt) running in the LaunchPad is shown on the previous page. It tells the chip on the solderless breadboard to set the LED brightnesses to get gradually larger and then smaller again. Then it makes the peak brightness move back and forth along the 14 LEDs, as if it were the scanning sensors on a Cylon robot, or KITT the Trans Am on *Knight Rider*.

To program the extra chip (the MSP430G2452), first carefully remove the MSP430G2553 chip from the LaunchPad. The chip is sensitive to static electricity, so you want to touch something that is grounded to get rid of any charge on your hands before touching the pins. Then place the chip on something conductive, such as a sheet of aluminum foil, to protect it from static electricity. Wearing cotton or wool clothing instead of nylon or polyester will also help reduce static electricity.

The pins on the extra chip may need to be straightened before they will fit into the socket. Many chips come from the factory with the pins splayed out just a little bit.

Once the new chip is inserted into the socket, you will need to remember to change the Tools/Board menu to let Energia know you are using the MSP430G2452 chip instead of the MSP430G2553 chip that was originally in the socket.

*Note:* If you want to test the chip by sending serial data to it, you will also need to change the TXD and RXD jumpers on the LaunchPad from the hardware UART setting to the software UART setting, since the extra chip does not have a hardware UART (universal asynchronous receiver/transmitter—i.e., serial port). But that step is not necessary if you aren't testing the new program from the host computer.

The next step is to program the chip with the Serial PWM code: http://artists .sci-toys.com/serial_pwm.txt.

Then disconnect the power, remove the chip from the LaunchPad, and place it in the solderless breadboard.

Now put the original MSP430G2553 chip into the LaunchPad, set the Tools/Board menu back to MSP430G2553, and load the program to send serial data (http://artists.sci-toys.com/send_to_serial_pwm.txt) to the chip in the breadboard.

When you connect the two chips' serial pins together and power everything up, you get a scanning LED pattern moving on the breadboard. The chip in the LaunchPad has outsourced the work of doing the pulse width modulation to the chip in the breadboard. Now the LaunchPad is free to spend its time doing other things, and it has 14 pins free to use for inputs and outputs.

You can connect several of the circuits together using four wires (power, ground, serial in, and serial out) as shown in the following photo:

Both of the solderless breadboards are lighting their LEDs in sync, controlled by the LaunchPad.

Controlling the extra chips this way means that you can change what all of the "slave" chips do just by changing the one program in the LaunchPad. You don't have to keep unplugging and plugging in chips when you want to make a change.

You can take things one step further and make it so you can control 16 of the extra chips individually. To do this, give each one an address. This is just an extra digit in the sequence you send to the chip. Each chip is programmed with a number from 0 to 15, which is its address. You send the address as the first character of the sequence. If the chip sees that the address it not its own, it simply ignores the command sequence.

The program for the slave chip is here: http://artists.sci-toys.com/addressable _serial_pwm.txt.

The program for the master chip is here: http://artists.sci-toys.com/addressable_send_to_serial_pwm.txt.

As the photo below shows, now the two slave chips are not merely mimicking one another in lockstep. You have turned your 14-LED Cylon into a 28-LED Cylon.

With 16 slave chips controlling 14 LEDs each, one master LaunchPad can control the brightness of as many as 224 individual LEDs. And if you need more, you can just add another digit of address, to control 3,584 LEDs.

Having lots of PWM pins comes in very handy when you want to control the color of a lot of RGB LEDs. Each RGB LED has a red, a green, and a blue LED inside the plastic lens, so it has four leads. It thus takes three pins to control the color (and brightness). One chip can control only four or five of these LEDs at a time before running out of pins. But with a slave chip, you have 28 pins available, so you can control 9 RGB LEDs and still have one pin left over.

You may have noticed that you are only using two wires (transmit and receive) to communicate between the various computers. How can they agree on what 0 volts means if they do not share a common ground connection? As it turns out, for short connections like this, the computers agree on a common ground whenever the lines are in the LOW state. For longer wires, the capacitance of the wire would delay this agreement by enough to cause problems, and you would

need to connect the grounds of the computers with another wire. But for short connections, this works.

## SYNCHRONOUS COMMUNICATION

The serial port and the Serial class that manages it deal with asynchronous communication. This just means that there is no shared clock in the two computers. Each computer has its own clock, and each expects the bits to have an agreed-upon duration. This means the computers need to agree on how fast the bits are sent. If one computer is sending data at 9,600 bits per second, and the other is expecting them to come in at 1,200 bits per second, they will not be able to communicate.

Synchronous communication uses another wire to send pulses that act as a clock. This means that the two computers no longer need to agree ahead of time on the speed of the communication, and thus the duration of the bits. The clock pulses tell the receiver when to look at the state of the pin receiving the bits.

The LaunchPad has hardware that makes it easy to use a form of synchronous communication called SPI, which is short for *Serial Peripheral Interface*. This method is used by many devices that need to communicate with the microprocessor, such as temperature sensors, barometric sensors, digital potentiometers (volume controls), radio interfaces, switches, and other input or output devices.

In the previous example of a serially controlled pulse width modulator for LEDs, each slave device was programmed with its own address and you sent the address as part of the serial data. SPI uses another wire to do the addressing. Each SPI slave device has a pin it can read to see if it has been addressed. The host SPI device sets a pin high to tell the slave it should listen to the data. In this way the host can communicate to as many slaves as there are spare pins to address them. And each slave can run the same software, since they don't need to be programmed with their own address.

So the SPI interface has four wires between the two devices. There is the clock (called SCLK); the master out slave in (MOSI), which is how the master talks to the slave; the master in slave out (MISO), which is how the slave talks to the master; and the slave select (SS) line, which tells the slave to listen.

Each slave shares the first three lines. Only one slave at a time is selected.

On the LaunchPad, SCLK is always pin P1.5, MOSI is always pin P1.7, and MISO is always pin P1.6. You get to choose which pin you use for the chip select (CS) function.

One big advantage you get from using a synchronous protocol is speed. Few asynchronous devices can reach a million bits per second, and the LaunchPad serial is limited to 9,600 bits per second when talking to the host computer. But the SPI clock can run at 8 million bits per second.

You don't always need that speed, so you use ordinary serial communications more often, as they use fewer pins. But fast communication comes in handy when you want to read external memory, such as the SDHC cards used in digital cameras. These cards can talk to the LaunchPad using SPI.

The photo above shows an SDHC card reader. The card slips into the large metal socket on the right. On the left you can see seven pairs of pins. You will only use six pins, since the card reader can run on either 5 volts or 3.3 volts and you only need the 3.3-volt pin. The second row of pins is not needed.

As you can see in that photo, the pins are labeled GND (ground), 5V, 3.3V, CS (Chip Select), MOSI, SCK, and MISO. All you need to do is connect those pins to their counterparts on the LaunchPad:

In this project, you will connect the pins using a six-strand ribbon cable with female sockets at each end. Follow the wires in the photo on the previous page to see how each labeled pin on the card reader is matched to the appropriate pin on the LaunchPad.

Dealing with all the complexities of reading files on the SDHC card is made easier by a library of routines you can load onto the LaunchPad. The version of this library that I used is in the file pfatfs.zip, and you can download it if you like, but the latest version can be found here: http://forum.43oh.com /topic/3209-energia-library-petit-fatfs-sd-card-library/, along with support from the people who wrote it.

When you installed Energia, a tree of folders was created on your computer. On my computer, the tree looks like the image at left.

To install the pfatfs library, you want to unzip the file into the energia/hardware/msp430 /libraries folder. It will then sit among your other libraries such as Servo and Stepper, and you can use it the same way you use them. On your machine, the Energia directory is named whatever you called it when you installed Energia. If you have forgotten where it is, search your computer for Servo or Stepper and you will find it.

The program on the next page (http:// artists.sci-toys.com/spock.txt) reads a file from the SD card and sends the data to a speaker using analogWrite():

- energia-0101E0009
- drivers
- examples
- hardware
  - lm4f
  - msp430
    - cores
    - libraries
      - IRremote
      - LiquidCrystal
      - MspFlash
      - NewPing
      - NRF24
      - PFatFs
      - Servo
      - SPI
      - Stepper
      - Wire
    - more_libraries
  - variants
- tools

spock_sdcard | Energia 0101E0009

File Edit Sketch Tools Help

spock_sdcard §

```
#include "SPI.h"
#include "pfatfs.h"

char buffer[ 256 ];

void
setup()
{
  Serial.begin( 9600 );
  delay( 100 );
  FatFs.begin( P2_2 );    // Port 2, pin 2 is the chip select on the card reader

  unsigned err;

  if( (err = FatFs.open( "spock.raw" )) != FR_OK )
  {
    Serial.print( "Can't open spock.raw: " );
    Serial.println( err );
    return;
  }

  pinMode( P2_1, OUTPUT );

  analogFrequency( 62500 );

  unsigned short len = 0;
  while( FatFs.read( buffer, sizeof buffer, &len ) == 0 && len )
  {
    for( unsigned i = 0; i < len; i++ )
    {
      analogWrite( P2_1, buffer[i] );
      delayMicroseconds( 30 );        // 8 bits at 11025 Hz
    }
  }
}

void
loop( void )
{
  digitalWrite( P1_6, 0 );    // stop the PWM timer
  delay( 1000000 );
}
```

Done uploading.
Done, 6716 bytes total
MSP430_Run
MSP430_Close

The first things you do are include the header files for the SPI and pfatfs libraries. The parts of the program that deal with the SD card are the FatFs class methods begin(), open(), and read().

Tell the begin() method which pin you have chosen to use as the Chip Select signal. Tell the open() method the name of the file you wish to open. Tell the read() method where to put the data, how much to read, and the address of a variable that will return how much was actually read (you may be near the end of the file).

That's how simple it is.

Almost.

There are some limitations on what you can do with the SD card. To keep the library small enough to fit on the LaunchPad, some limitations were introduced. File names cannot be longer than eight characters. You can overwrite bytes in a file, but you cannot create new files or make files longer.

To finish up this project, put a file on the SD card. The file I chose is a raw sound file, consisting of just a sequence of unsigned bytes. Most sound editing programs have the ability to output the sounds in raw format. In this case, the file is Leonard Nimoy's voice as science officer Spock, recording a message on his answering machine. The MP3 version of the file you can actually listen to right now is here: http://artists.sci-toys.com/nimoy_spock.mp3. The raw version to put on the SD card is here: http://artists.sci-toys.com/spock.raw. Right mouse on that last link and select Save As to download the file onto your computer.

To hear the message from Spock, you need a speaker. Below, I have chosen to amplify the speaker using a TIP31 transistor.

The left leg of the transistor is the base. It will be connected to pin P2.1 on the LaunchPad. The center pin is the collector. It is soldered to one of the speaker leads. The right pin is the emitter. It connects to ground on the LaunchPad. Finally, connect the other speaker lead to VCC (3.3 volts) on the LaunchPad. Using a transistor gets you plenty of volume out of the speaker.

Last, to make it portable, I soldered pins to the TP1 and TP3 holes next to the USB cable, so I can plug in a battery pack to yield nearly 5 volts.

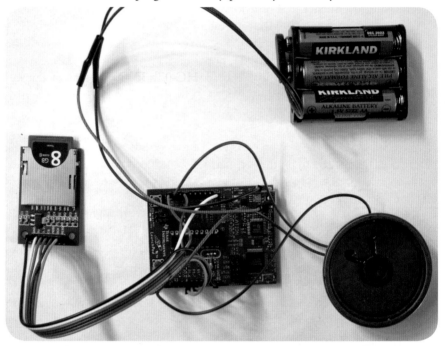

Now every time you push the Reset button or power up the LaunchPad, you hear Spock's answering machine message.

You are no longer limited by the small amount of flash memory on the LaunchPad when it comes to storing voice data. Where before you were limited to a little more than a second of sound, now you can store days and days' worth.

## BLUETOOTH

Using Bluetooth wireless communications with the LaunchPad is made easy by the HC-07 Bluetooth-to-Serial board. It is inexpensive (usually less than the LaunchPad costs) and will free you from needing a USB connection unless you are reprogramming the LaunchPad's chip. With the HC-07 board, you can talk

to the LaunchPad wirelessly, from across the room or even farther.

The HC-07 board is a little thing, smaller than my smallest finger. It has six pins, but you will only be using the four inside pins.

The pins are power (VCC), ground (GND), serial transmit (TXD), and serial receive (RXD). The board can run on anything from 3.3 volts to 6 volts, so you will use the LaunchPad's VCC, which is 3.3 volts.

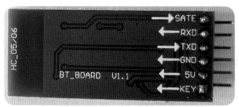

Connect the LaunchPad's port 1 pin 1 to the HC-07's TXD pin, and the LaunchPad's port 1 pin 2 to the HC-07's TXD pin. Connect power and ground and the hardware is ready to use. It's that simple.

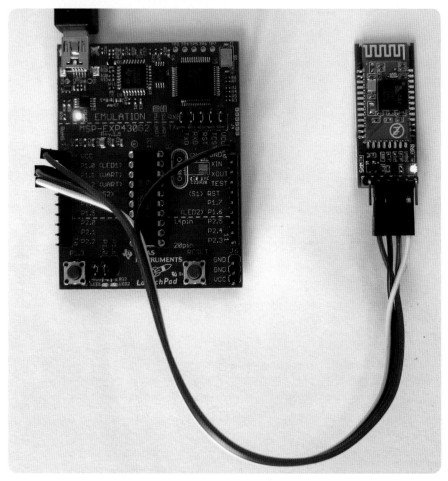

The board defaults to 9600 bits per second (baud), just like the LaunchPad does, so there is no configuration needed. You will run at faster speeds later, but for now, leave it in the default mode.

Start with a very simple program (http://artists.sci-toys.com/bluetooth_test
.txt) that simply prints a count to the serial port:

Now all you need to do is to connect to the Bluetooth device using your computer, cell phone, or tablet.

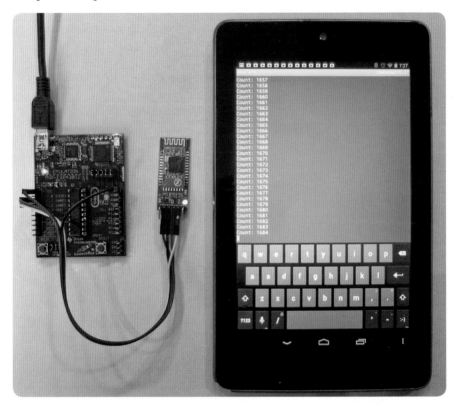

The photo above shows the LaunchPad talking to a Nexus 7 tablet (an Android device made by Google). The program it is running is BlueTerm, a free terminal program that lets you send and receive characters over Bluetooth as if you were connected by wires.

On my Windows laptop computer, I simply connect to the HC-07 using the Bluetooth Devices page and then use a terminal program such as PuTTY to connect to the COM port associated with the Bluetooth device I have connected to. In this case, it is COM25.

When connecting to the HC-07, the user is prompted for a PIN number. The default for the HC-07 is simply 1234.

Now that you know how to talk to the LaunchPad using Bluetooth, you can control your sculpture, robot, or work of art from your cell phone.

## INFRARED

You communicate with many of your devices in the home using infrared light. Your television remote control sends pulses of invisible infrared light to the television to change channels. Many toys have infrared remote controls. The LaunchPad computer can send and receive these signals, with the addition of an inexpensive infrared LED and infrared receiver.

My friend Ken Shirriff has written a library for the Arduino that takes most of the work out of decoding the signals. This library also works on the Launch-Pad and comes included with Energia. There are several examples in the File/Examples menu.

There are millions of ways to encode data onto a stream of pulses of light. Due to patents, trade secrets, and other competitive barriers to standardization, there are hundreds of schemes currently in use. The infrared library included with Energia supports six common schemes—NEC, Sony, RC5, RC6, Dish, and Sharp. So if you own a universal remote control, you can set it to one of those and the LaunchPad can receive its signals.

To receive the signals, you want an infrared receiver module.

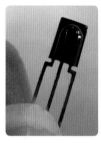

This is a three-terminal device (power, ground, and output). They come in different frequencies, but the most common is 38,000 hertz. Most remotes use 38,000 hertz. Those that use nearby frequencies (31,000 hertz, 36,000 hertz, etc.) will work with a 38,000-hertz receiver module, but the range will be smaller.

Connecting the receiver module to the LaunchPad is simple:

Power and ground are obvious, and the output (connected to P2.5) can be connected to any LaunchPad input pin.

The program to read the infrared signals (http://artists.sci-toys.com/simple _ir.txt) and send the results to the serial monitor is fairly simple.

simple_ir | Energia 0101E0009

File Edit Sketch Tools Help

simple_ir

```
#include <IRremote.h>

IRrecv receive_ir( P2_4 );

void
setup( void )
{
  Serial.begin( 9600 );
  receive_ir.enableIRIn();
  pinMode( RED_LED, OUTPUT );
}

const char *types[] =
{
  "UNKNOWN", "ERROR", "NEC", "SONY", "RC5", "RC6", "DISH", "SHARP"
};

void
loop( void )
{
  decode_results results;

  if( receive_ir.decode( &results ) )
  {
    digitalWrite( RED_LED, HIGH );
    Serial.print( "Type is " );
    Serial.print( types[ results.decode_type + 1 ] );
    Serial.print( ": Value is " );
    Serial.println( results.value );
    digitalWrite( RED_LED, LOW );
    receive_ir.resume();
  }
}
```

Done Saving.

23                                    LaunchPad w/ msp430g2553 (16MHz) on COM10

When you press a button on the remote, the serial monitor shows something like this:

```
Type is UNKNOWN: Value is 66207555
Type is UNKNOWN: Value is 66207555
```

The type is listed as UNKNOWN because I was using a DirecTV remote, which uses a different protocol than those the library knows about. Two values are shown because most remotes send the code more than once for each button press, to make sure the message gets through. Sometimes a special code is used for "repeat." For the purposes here, you can ignore that special code.

Suppose you want to use the remote to control a robot. The remote has some buttons that form a little circle, and you can interpret those buttons as forward, backward, left, and right, and the middle button can be beep, or fire, or whatever you like. If you push the buttons in that order, you see:

```
Type is UNKNOWN: Value is 4064352766
Type is UNKNOWN: Value is 3028878891
Type is UNKNOWN: Value is 3308754100
Type is UNKNOWN: Value is 197779206
Type is UNKNOWN: Value is 1974032039
Type is UNKNOWN: Value is 744425775
```

The center button, marked SELECT, sends one code multiple times while the button is held down, then another code when the button is up. You will interpret that as Fire! and Cease Fire! respectively.

Now you can write a new program (http://artists.sci-toys.com/directv _remote.txt) that shows you the commands that you would use to control the robot.

DirecTV_remote | Energia 0101E0009

File  Edit  Sketch  Tools  Help

DirecTV_remote §

```
#include <IRremote.h>

IRrecv receive_ir( P2_4 );

void
setup( void )
{
  Serial.begin( 9600 );
  receive_ir.enableIRIn();
  pinMode( RED_LED, OUTPUT );
}

enum codes
{
  FORWARD  = 4064352766,   BACKWARD = 3028878891,
  LEFT     = 3308754100,   RIGHT    = 197779206,
  SELECT   = 1974032039,   DONE     = 744425775
};

void
loop( void )
{
  decode_results results;

  if( receive_ir.decode( &results ) )
  {
    unsigned long int code = results.value;
    digitalWrite( RED_LED, HIGH );
    if( code == FORWARD )        Serial.println( "Forward" );
    else if( code == BACKWARD ) Serial.println( "Backward" );
    else if( code == LEFT )     Serial.println( "Left" );
    else if( code == RIGHT )    Serial.println( "Right" );
    else if( code == SELECT )   Serial.println( "Fire!" );
    else if( code == DONE )     Serial.println( "Cease Fire!" );
    else                        Serial.println( code );
    digitalWrite( RED_LED, LOW );
    receive_ir.resume();
  }
}
```

Done uploading.

Done, 8600 bytes total
MSP430_Run
MSP430_Close

34                                         LaunchPad w/ msp430g2553 (16MHz) on COM10

Pressing the keys on the remote now shows you:

```
Forward
Forward
Forward
Backward
Backward
Backward
Left
Left
Left
Right
Right
Right
Fire!
Fire!
Fire!
Cease Fire!
Fire!
Fire!
Fire!
Fire!
Fire!
Fire!
Fire!
Cease Fire!
```

Sending infrared codes from the LaunchPad to some other device is also fairly simple, thanks to the infrared library. You will need an infrared LED to send the signals.

You can use the infrared LED the same way you use a visible-light LED. However, it is not possible to tell whether it is working just by looking at it, because you can't see infrared light. But you can use a trick. You can aim a camera (such as the one in your phone) at the infrared LED and watch the flashes on the camera's screen, since the digital sensor in the camera is sensitive to infrared.

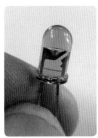

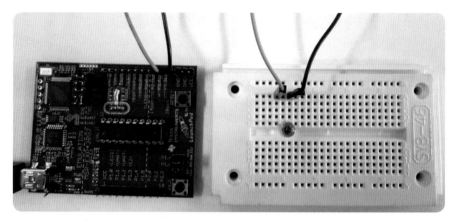

Connect the LED to P2.3 and ground. The long lead is the *cathode* (which connects to ground). The short lead is the *anode*, and it connects to P2.3.

You are now going to use the infrared LED to control a small toy tank.

You can use the previous program to see what the signals from the tank's remote look like. Unfortunately, they are not sent using one of the coding methods known by the library. However, you can extend the library so that you can control the tank.

The library collects the bits that the remote sends to the LaunchPad. You can print out those "raw" numbers, which tell you how long the LED was on and how long it was off, for each of the flashes the remote makes as it sends the code. By looking at those numbers, I found that the tank's remote started each command with a flash that lasted 1.772 seconds. Then there was a dark period of 0.34 seconds. That sequence marked what is called the header.

To send a 1-bit, the tank flashes the LED for 0.36 seconds, followed by a dark period of 0.82 seconds.

To send a 0-bit, the dark period is only 0.34 seconds.

There are five bits sent for each command. That allows 32 different commands to be sent.

Using this information, you can now extend the library's IRsend() class. You will call your class "tank" and grant it all of the functions of the IRsend class by telling Energia that your "tank" class *inherits* from IRsend. The line that does that looks like this:

```
struct tank : public IRsend
```

Now here's what the code for the new "tank" class (http://artists.sci-toys.com /tank_irsend.txt) looks like:

You have created a new method, called sendTank(), that will flash the infrared LED in just the right sequence to send your commands to the tank. Now you can look at the rest of the program as it uses the new class to send commands to the tank:

```
void
setup( void )
{
  Serial.begin( 9600 );
  P2DIR |= BIT3;
  P2SEL |= BIT3;
}

enum
{
  LEFT_FORW = 1, LEFT_BACK = 2, RIGHT_FORW = 3,
  RIGHT_BACK = 4, ALL_FORW = 5, SPIN_RIGHT = 6,
  SPIN_LEFT = 7, ALL_BACK = 8, CONTINUE = 31
};

void
loop( void )
{
  for( int x = 0; x < 6; x++ )
    t.sendTank( ALL_FORW );
  delay( 1000 );
  for( int x = 0; x < 36; x++ )
    t.sendTank( SPIN_RIGHT );
  delay( 1000 );
  for( int x = 0; x < 6; x++ )
    t.sendTank( ALL_BACK );
  delay( 1000 );
}
```

You send the tank forward, then spin it right for a while, and then make it move backward.

Sending the number 0b00001 (that's just the number 1) to the tank moves its left tread forward. Sending a 0b0010 to it (the number 2) moves the left tread backward. Sending a 5 moves both treads forward, and so on.

# 9

# PROGRAMMING

Up to this point this book hasn't talked much about how to write code for the LaunchPad. You have seen many examples, and learning by example is often the fastest way to get something done. But at some point a more organized approach is needed. You have reached that point.

The programming language you have been using on the LaunchPad is C++. There are many good books on C++ programming and hundreds of free online tutorials for the language. This chapter will concentrate on the simple parts of the language that are the most used, but you will skip over whole sections of the language that are more advanced and complicated and that are rarely (if ever) used on small computers like the LaunchPad.

A C++ program usually starts with a function called main(). When using Energia, the main() function is actually hidden in the startup code. The hidden main() function calls your by-now-familiar setup() routine once and then calls the loop() function over and over again forever. So if you are reading a tutorial about C++ and are wondering where the main() function is, now you know.

A function is a bit of code that does something when it is called. Every bit of code that does something is inside some function or another. The familiar setup() and loop() functions are good examples.

The simplest functions don't return values to the code that calls them. The setup() and loop() functions are two examples of functions that don't return values. You tell the C++ compiler that the function has no return value by putting the keyword "void" in front of the function name. If the calling code does not pass any information to the function, you also use the keyword "void" to indicate that, by putting it inside the parentheses after the function name.

This is why the setup() and loop() functions look like this:

```
void
setup( void )
{
}
```

```
void
loop( void )
{
}
```

## DATA TYPES

If you want a function to add two numbers together, you would need to tell the compiler about the types of numbers you want to add. They can be integers or they can be floating-point numbers (so you can express fractions). Either of those types can come in different sizes, with the larger sizes able to hold bigger numbers.

On the LaunchPad, the integer types are

```
char
short
int
long
```

The floating-point types are

```
float
double
```

The char type is 8 bits (it can hold numbers from –127 to 127). The short type and the int type are actually the same on the LaunchPad, each holding 16 bits (–32,767 to 32,767). The long type is 32 bits (–2,147,483,647 to 2,147,483,647).

The float type is 32 bits, and the double type is 64 bits. They can handle both huge numbers and very tiny numbers, but they are slow on the LaunchPad because the LaunchPad has no dedicated hardware for calculating with floating-point numbers.

So here is what the function to add two 16-bit integers would look like:

```
int
add( int a, int b )
{
   return a + b;
}
```

The first int keyword tells the C++ compiler that the add() function will return a 16-bit integer.

The declarations inside the parentheses tell the compiler that the add() function takes two 16-bit integer arguments, which will be referred to in this function as *a* and *b*.

The return statement returns the 16-bit value that results from adding *a* to *b*.

The function that calls the add() function might have a statement that looks like this:

```
int answer = add( 14, 92 );
```

This declares a new variable called "answer" that holds a 16-bit integer. The new variable will now hold the value returned by calling the add() function with the numbers 14 and 92. The answer variable can then be used later as input to other functions or calculations. For example, you might want to delay by that number of milliseconds:

```
delay( answer );
```

Sometimes you want to give a name to a number. This makes it easier to understand what the number is used for, and it makes it easy to change all of the places where the number is used, all at once. You have seen many examples of this earlier—you use the enum statement to do this:

```
enum { HOW_MANY_MILLISECONDS_TO_DELAY=50, WHICH_PORT_TO_USE=P1_5 };
```

If you omit the equal signs, the enum statement will assign 0 to the first name, 1 to the second, 2 to the third, and so on.

## CONSTANTS

Constants are things that don't change. Numbers are constants, like 3 or 98.

You can also have character constants that store letters of the alphabet or punctuation. You enclose these in single quotes, as in 'A' or '+'.

(If you want to indicate the single-quote character, put a backslash in front of it, as in \'. To indicate a backslash, put two backslashes: \\. This is called "escaping" the single quote, or escaping the backslash.)

You can store strings of characters using double quotes, as in "Please push the button".

Numbers can be integers like 123, or floating-point numbers, like 13.88 and 0.003.

Sometimes it is helpful to use number bases other than 10 to describe constants.

The constant 0b111 means to set all three of the lowest bits to 1. This is the same as the decimal value 7. The 0b means the number is in binary (base 2).

You can use base 8 (called octal) by putting a zero in front of the other digits (since the 0 looks like the o in octal). Thus 017 is the same as the decimal number 15.

You can use base 16 (called hexadecimal) by putting a 0x in front of the other digits and using the letters *A* through *F* to indicate the numbers you can't express in decimal. Thus 0xA is the same as decimal 10, and 0xF is the same as decimal 15, and 0xFFFF is 16 bits that have all of the bits turned on (the same as 0b1111111111111111).

## ASSIGNMENT

You can copy information into variables:

```
how_many_cats = 14;
```

You can copy the information in one variable into another:

```
how_many_tails = how_many_cats;
```

You use a single equal sign to indicate that the variable on the left gets changed to the value stored in the variable on the right. Nothing happens to the information in the variable on the right (it does not change or get lost anywhere).

If you put a value from an 8-bit integer variable into a 16-bit integer variable, it fits just fine, and all is well.

If you put a value from a 16-bit variable into an 8-bit variable, only the low eight bits get stored. The high eight bits are ignored. Thus the expression:

```
char eight_bits = 0b1001001001;
```

would put the value 0b01001001 into the variable called eight_bits and ignore the two high bits.

## EXPRESSIONS

You can do calculations on your variables and constants by using operators such as plus and minus:

```
int just_a_little_more = a_little + 1;
```

The operators * and / are used for multiplication and division:

```
int pressure = psi / (width * height);
```

The last two variables are grouped in parentheses to indicate that the multiplication should be done first, then the division. Otherwise the result would have been the same as (psi / width) * height.

Multiplication and division are done before addition and subtraction:

```
int price = cost_of_cup + cost_of_coffee * ounces_of_coffee;
```

The other arithmetic operators are the *unary minus sign*, used to negate a number or variable (such as -1, -price, or -(tax+license_fee)); the modulo operator % (which is the remainder after division, so 5 % 3 is 2); and the increment and decrement operators ++ and --, used to add or subtract 1 from a variable. These last two operators change the variable they are used on. If they are used before a variable, they change the variable before its value is used in the rest of the expression, so in the bit of code:

```
int seconds = 0;
time = ++seconds + 13;
```

the value of time would be 14. If the code looked like this:

```
int seconds = 0;
time = seconds++ + 13;
```

then the value would be 13. In both cases, the value of seconds after the last statement would be 1.

The C++ language has a large number of operators for constructing expressions, and you have seen examples earlier of the "shift" operators >> and <<, the "and" operator &, the "or" operator | and the exclusive-or operator ^. All of these operators have their "precedence" much as multiplication happens before addition. But if you string together a lot of operators, my suggestion is to use parentheses to group them rather than trying to remember all of the precedence rules. Your code will then be readable by people who have forgotten whether shifts happen before exclusive-or.

To compare values, there are relation operators. These are ==, !=, >, <, >=,

<=, for equal to, not equal to, less than, greater than, greater than or equal to, and less than or equal to. These are most often used in "if" statements and loop controls, but they can also be used as arithmetic operators, evaluating to 1 for true and 0 for false.

Likewise mostly used in control flow statements are the logical operators !, &&, and ||, for NOT, AND, and OR. An interesting feature of the || operator is that if the first operand is true, the expression after the || is ignored, since it will not change the value. This is true even if it has some effect, such as incrementing, assigning, or calling a function. The same is true of the && operator if the first operand is false.

The bitwise operators are ~, &, |, ^, <<, and >>, for complement, AND, OR, XOR, left-shift, and right shift.

The complement of a number is where each bit is the opposite of what it used to be:

```
int pins = 0b11010;
int not_pins = ~pins;
```

The value of not_pins is 0b101.

When you use the & operator, the result has a 1 bit only if the corresponding bits in each operand are 1. Thus in:

```
int pins = 0b11010;
int not_pins = pins & 0b111;
```

the variable not_pins would have the value 0b10.

When you use the | operator, the result is a 1 bit if either of the corresponding bits is 1:

```
int pins = 0b11010;
int not_pins = pins | 0b111;
```

and not_pins ends up with the value 0b11111.

When you use the ^ operator (exclusive or), the result is a 1 bit if one or the other corresponding bits is 1, but not both (the "exclusive" adjective):

```
int pins = 0b11010;
int not_pins = pins ^ 0b111;
```

and not_pins ends up with the value 0b11101.

The shift operators move all the bits left or right by the amount given in the second operand:

```
int pins = 0b11010;
int not_pins = pins >> 2;
```

gives the value 0b110 to the variable not_pins.

For the operators that take two operands, you can simplify assignments by combining the operator with an equal sign. Thus these two statements result in the same action:

```
a = a + c;
a += c;
```

## CONTROL FLOW

You have seen several examples of control flow statements. The simplest is the *if* statement:

```
if( x < 13 )
  delay( x );
```

You can also add an *else* statement after it:

```
if( cost < bank_balance )
  buy_it();
else
  walk_away();
```

Another simple control flow statement is the *while*:

```
while( ++day < DAYS_PER_WEEK )
  salary += ONE_DAY_PAY;
```

A little more complicated is the *for* statement, which has three parts—the initialization, the condition, and the loop expression (where the control variable is usually modified):

```
for( int a = 0; a < HOW_HIGH; ++a )
  jump();
```

All three parts are optional—the most reduced form is for(;;), which means to loop forever.

If you want to group several statements together so they can be controlled by an *if*, a *while*, or a *for*, simply put curly braces around the group of statements:

```
if( today == TUESDAY )
{
    do_the_laundry();
    walk_the_dog();
    call_mom();
}
```

Comments are any text after two forward slashes. Everything from the slashes to the end of the line is ignored by the compiler.

Statements end in a semicolon, as you have seen in all of the examples in this book.

## LIBRARY FUNCTIONS

Energia provides a convenient library of built-in functions you can use in your programs. If you click on the Help button in Energia, it will bring up the Arduino Language Reference page, since Energia is based on the older Arduino platform. That is where you will find the documentation for many of the functions you have used in the examples in this book, such as pinMode(), digitalWrite(), analogRead(), etc.

Most of those functions are known to the compiler already. Others, such as the Servo class, are in extra libraries, and you need to include a header file before you use them. The Arduino Language Reference page you get when you click on the Help button in Energia has a link to the library page, where several libraries are described. In addition, you can create your own libraries.

## SLIGHTLY MORE COMPLEX ISSUES

For most simple programs, nothing more than the elements discussed so far are needed. But some additional information can make hard problems simple.

The first thing to discuss is called *scope*. This is the concept that variables have a lifetime, and which corresponds to where they are in the program.

If a variable is declared outside of a function, it is said to have *global scope*. That means that all functions after the variable is declared can see and use that variable.

If a variable is declared inside a function (or as a parameter to the function), it has *function scope*. It is known only inside that one function. If another function declares a variable with the same name, it is a new and entirely separate variable.

The space that variables in function scope occupy is released when the function returns, and that space can then be used by other functions for their own variables. This is important when you have a lot of data in your program and your microprocessor chip only has 512 bytes of data to use for everything.

You can also declare variables inside any block of statements enclosed in curly braces. When the program leaves that block, the space is reclaimed, just as if a function had returned.

Inside a *for* statement, you can declare the variable used to do the counting. The scope of that variable is the *for* statement and the block or statement the *for* controls. This is handy for simple variables you just use for counting, such as *i* or *x*.

If you want to prevent a variable from being reclaimed when it goes out of scope, you can declare it static. A static variable keeps its value across function calls or when exiting blocks.

## Complex Data Types

Sometimes you want to group data together. The simplest example of this is the array.

An array is just a bunch of simple data types strung together one after the other so they can be indexed by a counting variable. You have used arrays several times in the examples in this book. Arrays are declared by putting their size in square brackets after the name of the variable:

```
unsigned char values[14];
```

If the array is initialized by putting values in curly braces after an equal sign, then the compiler can count the number of items itself, and you can omit the number in the square brackets:

```
unsigned char values[] = { 0, 1, 2, 3, 4, 5, 6, 7, 8, 9, 10, 11, 12, 13 };
```

You can retrieve the values in the array by using an index inside square brackets:

```
for( int x = 0; x < 14; x++ )
    sum += values[x];
```

Sometimes you want to group different types of data into one bundle, to keep them all in one place. You use a structure for that:

```
struct Throb
{
  int brightness;
  int pin;
  int increment;
};
```

You can then declare an instance of that structure by using the structure name:

```
Throb first_led;
```

To use the variables inside the structure, join them to the variable with a period:

```
first_led.pin = P1_4;
first_led.brightness = 44;
first_led.increment = 2;
```

Structures can be initialized by a function called a constructor. It is a function that has no return value (not even void) and has the same name as the structure:

```
struct Throb
{
  int brightness;
  int pin;
  int increment;
  Throb( int b, int p )
  {
    brightness = b;
    pin = p;
    increment = 1;
  }
};
```

Arguments to the constructor are passed in when the variable is declared:

```
void
setup( void )
{
  Throb first_led( 44, P1_4 );
}
```

Structures can have functions inside them besides the constructor. Those functions can see the variables inside the structure and can change them.

```
struct Throb
{
  int brightness;
  int pin;
  int increment;

  Throb( int b, int p )
  {
    brightness = b;
    pin = p;
    increment = 1;
    pinMode( pin, OUTPUT );
  }

  void change( void )
  {
    if( brightness > 100 )
      increment = -1;
    else if( brightness < 0 )
      increment = 1;
    brightness += increment;
    analogWrite( pin, brightness );
  }
};
```

These functions inside structures are called "methods." The change() method in the Throb structure changes the brightness of an LED every time it is called. It remembers the previous brightness so it can slowly ramp the brightness up and down if it is called many times.

All of the internal variables and methods in a structure are public and can be used, changed, and called by any function. If you have data you want to protect from other functions, you can declare it private:

```
struct Throb
{
private:
  int brightness;
  int pin;
  int increment;

public:
  Throb( int b, int p )
  {
    brightness = b;
    pin = p;
    increment = 1;
    pinMode( pin, OUTPUT );
  }

  void change( void )
  {
    if( brightness > 100 )
      increment = -1;
    else if( brightness < 0 )
      increment = 1;
    brightness += increment;
    analogWrite( pin, brightness );
  }
};
```

A type of structure where everything is private unless you declare it otherwise is called a class. You can see the Throb class in use in this example: http://artists .sci-toys.com/Throb.txt.

That example uses the operator called new. The new operator creates space for the class and calls the constructor. This space is not freed up to be used by other functions until it is destroyed, using the delete operator. In a tiny computer like the LaunchPad, this kind of memory management is seldom used.

## Pointers

The Throb class described in the previous section used pointers to the three instances of the class Throb.

A pointer is declared by putting an asterisk in front of the variable name:
Throb *a, *b, *c;

You can have pointers to integers, chars, floats, doubles, structs, or anything that has a memory address. A pointer is simply a number that says where in memory some object is.

To use a pointer to a simple type, just put an asterisk in front of the variable name:

```
int values[14];
int *pointer_to_value = &values[4];
*pointer_to_value = 19;
```

The ampersand gets the address of the object so you can store it in the pointer.

If the object is a struct or a class, you use the arrow operator to reference things inside the structure:

```
a->change();
```

This says to call the change() method of the Throb object that the pointer a points to.

Pointers can be very useful in large, complicated programs but are not often seen in programs that run on tiny microcontrollers.

You can get the address of a function and use a pointer to call that function. This can be handy when you want to have an array of things that the program can do and select a function from the array. You could make your Rover (see page 142) dance randomly:

```
typedef void (*function)( void );

function list[] =
{
  forward,
  reverse,
  stop,
  forward_right,
  forward_left,
```

```
    spin_right,
    spin_left,
    reverse_right,
    reverse_left
};

void
dance( void )
{
    for( ;; )
      (*list[random(9)])();
}
```

This code says to define a type (that's the typedef operator) called function that is a pointer to a function that takes no arguments and returns no value. Then it uses that type to declare a list of addresses of functions (the motion functions you already have in the Rover program). Then the dance() function picks a random number from 0 to 9 and uses that as the index to pick a function to call.

Again, this kind of thing is rarely done on tiny computers.

# INDEX